UNDER *the* SEA

MASAKI 水沒場景模型作品集

關 真生（MASAKI）／著

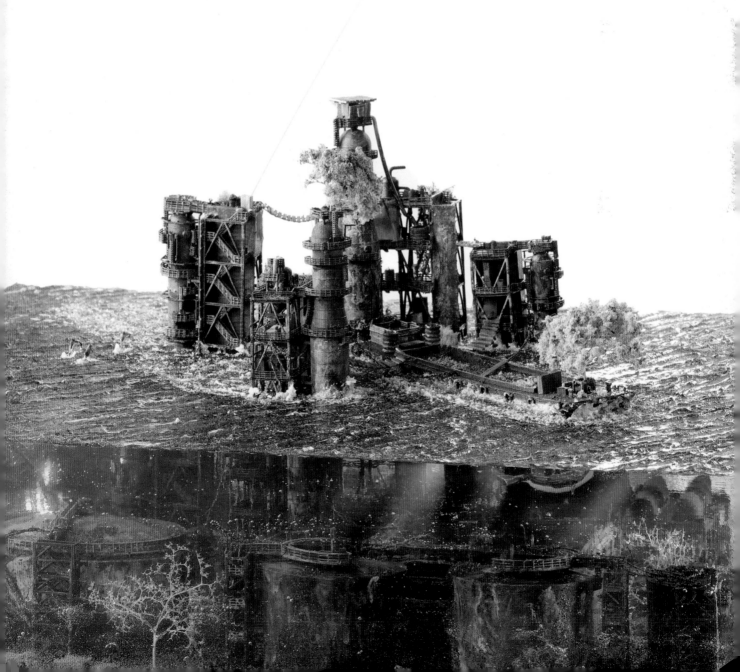

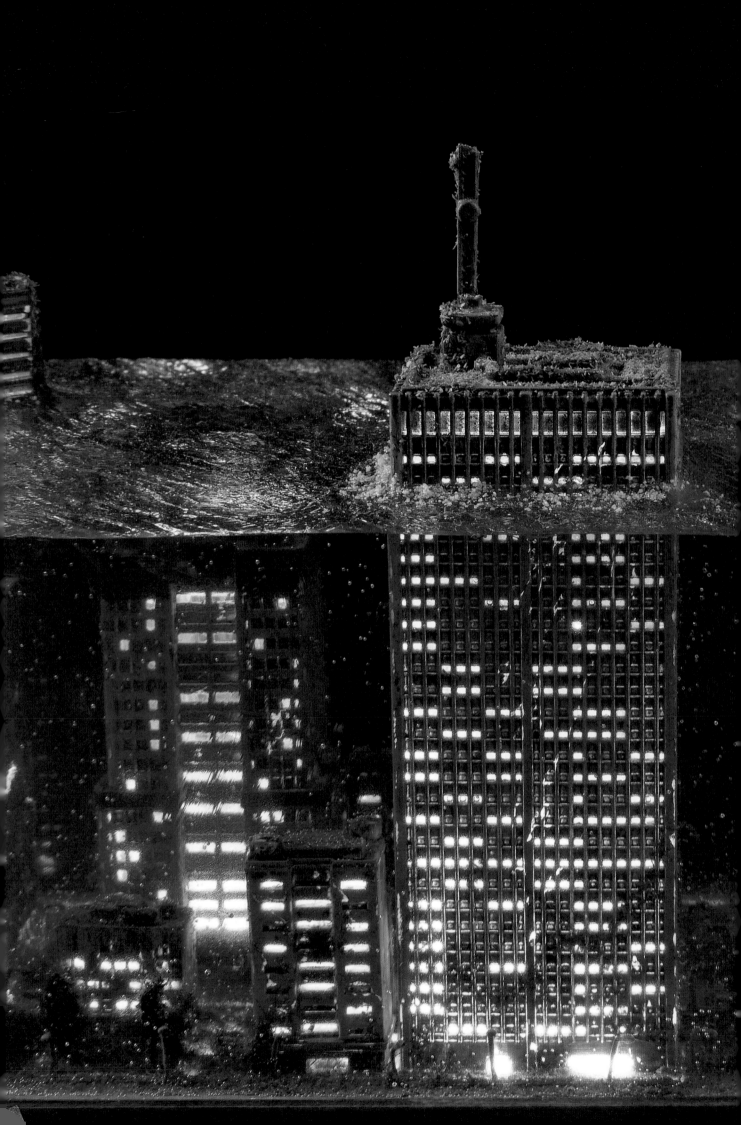

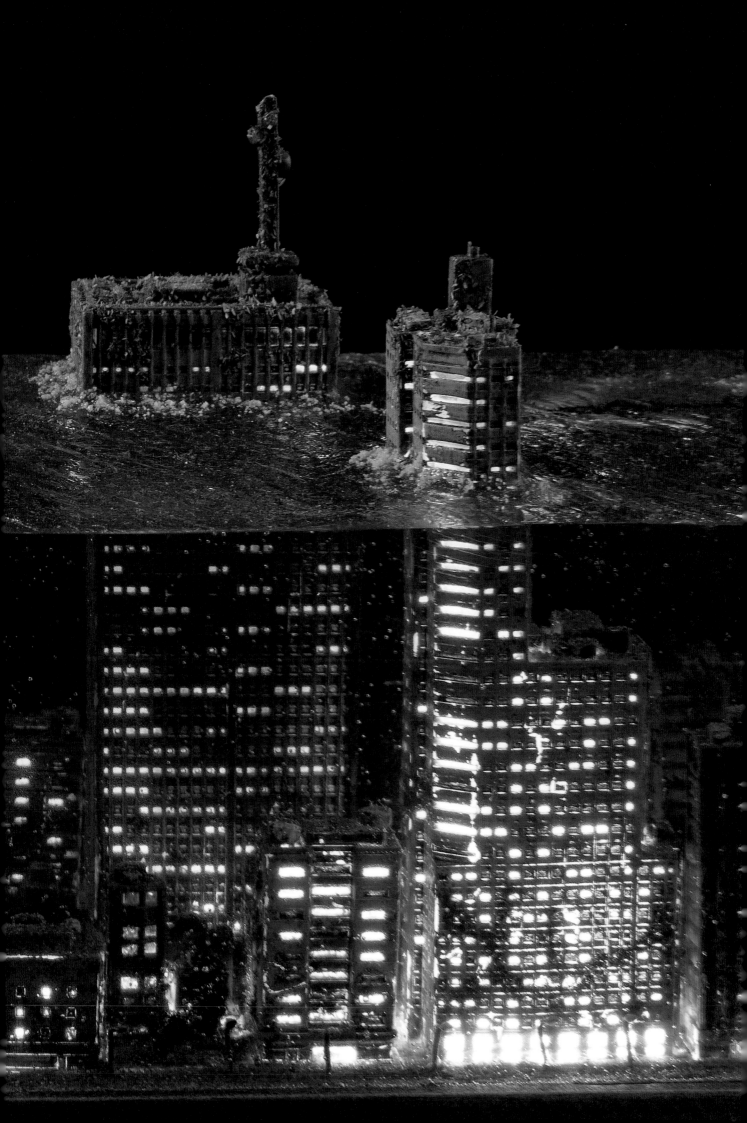

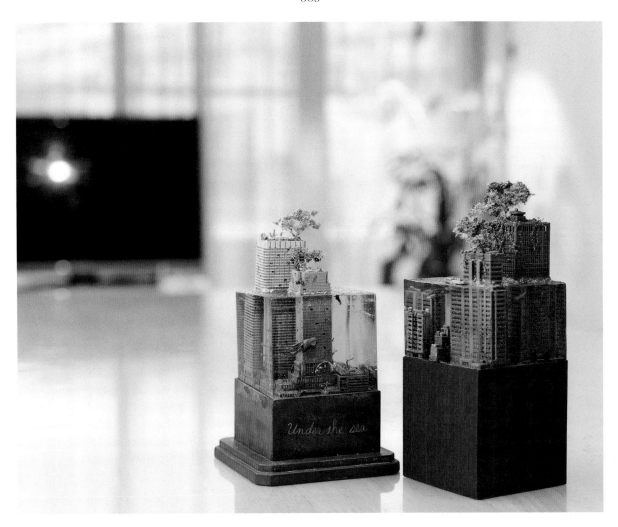

Introduction

MASAKI 老師的水沒場景模型,有著相當獨特的溫柔觀點。

那場景宛如來到已滅亡之地球做探索訪問的外星人,

用了超高科技,將世界的斷片切割出來、保存成爲標本似的,美麗之中也充滿了憐愛感。

我認爲 MASAKI 作品的魅力,正是他如學者般深思熟慮的視點。

作品就是映照出作者的明鏡。

MASAKI 老師的作品,毫無保留地直接表現出他溫和穩重的個性,

想必能夠超越模型或立體透視微縮模型的領域,讓粉絲持續不斷地增加。

身爲他的朋友,我打心底確定他一定會成功的。

MASAKI's submerged dioramas have a unique and gentle perspective. It is as if aliens who visited the destroyed earth have used super-technology
to cut out fragments of the world and make them into specimens. I think that the scholarly and thoughtful viewpoint is the charm of MASAKI's works.
His works are mirrors of the artist. MASAKI's works, which express his gentle personality as it is, will continue to gain fans
beyond the framework of models and dioramas. As a friend, I sincerely believe in his success.

太田垣康男

漫畫家(株)スタジオ‧トア的負責人。1967年3月31日出生於日本大阪府。
代表作品有『MOONLIGHT MILE』、『機動戰士鋼彈 雷霆宙域戰線』、『機動戰士鋼彈 雷霆宙域戰線外傳』、『Get truth太陽の牙』,
其中以漫畫為原創的『機動戰士鋼彈雷霆宙域戰線』鋼彈漫畫作品更是空前未有的熱門暢銷,
至本書出版前已累計銷售超過470萬本,現在也仍在青年漫畫半月刊雜誌『BIG COMIC』連載中。

MASAKI　關 眞生

Born in October 1969 in Kadoma City, Osaka Prefecture. In his childhood, he bought plastic models at a candy store and enjoyed assembling them, which was a boy's way of life in those days. During his adolescence, he naturally left plastic models and immersed himself in his hobbies, such as computers, and found a job. After working as a photoengraver for a printing company, he entered the world of computer graphics and video production in 1995, and moved to Tokyo in 1999 for work. In 1999, he moved to Tokyo for work, and in 2007, he returned to model making, and in 2008, he started making dioramas. In 2014, he won a top prize in a model magazine contest, and in 2015, he debuted as a writer for a model magazine.

In 2016, his submerged diorama was featured in the morning news program "Mezamashi TV" (Fuji TV) and appeared on TV. In 2017, "Amayadori" won the Grand Prix in the existing kit category at the Hamamatsu Diorama Grand Prix; from the end of 2017 to February 2018, a special exhibition "10 Years of MASAKI Diorama" will be held at the Hamamatsu Diorama Factory; in the summer of 2022, the first solo exhibition of only original works will be held at HOWHOUSE in Yanaka, Taito-ku, Tokyo. A solo exhibition of only original works, "Submerged World Dioramas," was held at HOWHOUSE in Yanaka, Taito-ku, Tokyo in the summer of 2022.

He is still one of the most active creators of submerged dioramas in model magazines and on the web.

1969 年十月生於日本大阪府門眞市。小時候也和那個時代的男孩子們一樣，會從雜貨店買塑膠模型回來組裝著玩，並相當樂在其中。青少年時期就自然不再玩模型，而是一頭栽進電腦之類的興趣中，就這樣一直維持到出社會工作。先是在印刷公司從事照相製版工作，1995 年則投入 CG 製作及影像製作的世界裡。1999 年，因工作的需要而移住東京都。從 2007 年開始又重新回頭製作模型，2008 年起開啟了他的場景模型製作之路。小時候買不起或買不到的材料、工具，終於都能一一收集起來，藉由雜誌或網路的普及，還可輕鬆獲得各式各樣的情報，更讓他沉迷於其中，無法自拔。2014 年，在模型雜誌舉辦的創作大賽中名列前茅。2015 年，成爲模型雜誌的作者之一。

當時他利用市售的「GEOCRAPER」(以現實中各種建築物爲藍本，所製作的迷你模型)，想做出一些更有趣的表現，便試著做出水沒場景模型，在推特 (現在的 X) 上引起很大的迴響。2016 年時，晨間新聞節目『めざましテレビ (富士電視台)』報導介紹了他的水沒場景模型。2017 年時更在濱松場景模型大賽中以「あまやどり (屋檐下躲雨)」獲得既成組件部門的優勝賞。從 2017 年末到 2018 年 2 月期間，在浜松ジオラマファクトリ (Hamamatsu Diorama Factory) 推出企劃展「MASAKI 場景模型 10 年的軌跡」。2022 年夏天在東京都台東區谷中的 HOWHOUSE，初次以完全原創的作品開設個展「水沒後的世界之場景模型」。

現在也仍以水沒場景模型爲中心，以創作者的一員活躍於模型雜誌及網路中。

What's a "Submerged Diorama"?
什麼是水沒場景模型？

「在非日常中感受到的日常」
大樓、街道、集合式住宅、甚至是機械人們，都靜靜佇立在樹脂凝聚成的水中——……。
MASAKI 製作出的「水沒場景模型」，和這句話的氛圍十分契合。
他的作品，讓我們看見海中與海上兩種不同的面貌。
本書使用 MASAKI 親自命名的「水沒場景模型」這個名稱，
向讀者們一一介紹各種各樣的作品。

The ordinary life within the extraordinary day. Buildings, towns, apartment complexes, and robots stand in the water called "resin" -
Such words fit well with the "submerged dioramas" created by MASAKI. These works show different faces underwater and above water.
In this book, MASAKI himself named "Submerged Diorama" and introduces a number of his works. I would like to introduce a number of his works.

閱讀本書前應先瞭解之有關樹脂鑄型的二三事

使用環氧樹脂類樹脂鑄型方式製作水沒場景模型時的注意事項。　Points to make a note of when using epoxy resin to create a submerged diorama.

關於樹脂鑄型(以下皆略稱爲樹脂)

About the resin.

■作者使用的是雙液型的環氧樹脂，將主劑和硬化劑依照一定的比例慢慢混合後就會硬化的透明樹脂。和照射紫外線才會硬化的 UV 硬化型樹脂液不同，請務必注意。

Masaki uses two-component epoxy resin. This type of resin hardens when the primary solution and the hardener are mixed together in a specific ratio. Do not mix up the two-component epoxy resin with the kind of resin cured by UV light.

■ UV 硬化型的樹脂液一旦流進較深的部位，或是滲進組合交接處，也會因爲紫外線照不到，而產生硬化不良的現象，所以不推薦使用。

UV resin is not suited for deep pours. The UV light might not reach into intricate areas of the diorama, such as the interior of a building.

■就算是環氧型的樹脂，請儘可能選用耐黃變性較高的產品。有些產品可能僅過了幾個月，就變黃、變混濁，那就太令人失望了，所以就算價格較昂貴，也請選購大家都公認耐黃變性較高的產品爲宜。

Choose an epoxy resin with high resiliency to yellowing. Some resin tends to lose clarity and become yellowish after only a few months. So, pick ones that are said to have a high resiliency to yellowing, even if it is a little expensive.

■就算是環氧型的樹脂，硬化時間較長的產品，會比較不容易發生表面凹陷，也更容易將氣泡去除。黏度較低或是流動性較高的產品較容易流進細小複雜的部位，氣泡也很容易就能去除。

Epoxy resin with a longer curing time will have less tendency to create sink marks and trap bubbles. A resin with low viscosity will have a much easier time seeping into intricate parts.

■筆者從以前使用到現在的クリスタルレジン NEO 預定要停止販售了（此文寫於 2023 年 4 月）。我試過 SK 本舗的雙液型環氧樹脂，以及販售場景模型素材的「さかつう」網站才有在賣的プロクリスタル 880，兩者用起來的感覺都和クリスタルレジン NEO 的印象很接近。

Unfortunately, my go-to resin, the Crystal Resin NEO, is being discontinued. I have found that the two-component epoxy sold by SK-Honpo, or the Pro Crystal 880, performs very closely to the Crystal Resin NEO.

■有時候網路商店也會販賣價格外便宜、品質很差的產品，要特別注意。

Many types of resin are being sold online, but be aware that some cheaper products could be of poor quality.

在製作要沒入樹脂液的模型時

When building objects to submerge.

■模型部件有時候會出現空氣停滯在內部空間裡的狀況，後續在硬化時產生的高溫會使空氣膨脹，因而冒出氣泡。所以爲了不讓空氣被密封在內部，就要在比水面更高的地方開個小孔，讓空氣能夠排出，或是將內部的空洞填滿封住，事先將這些工作做好，才能避免氣泡產生。

Air trapped inside the building and other objects could escape during the resin pour and appear as bubbles. To prevent air from seeping out the bottom, make a hole in the buildings/objects above the waterline. Alternatively, you could completely fill the space inside the buildings prior to pouring in resin.

■即使將空洞的部件完全黏著或完全密封住，仍有可能因爲硬化產生的熱量而使空氣膨脹，導致出現微小的空氣縫隙，或是膨脹的空氣使黏接面發生開裂、冒出氣泡等。

Even if you completely secure hollow objects by firmly gluing them to the ground, the heat from resin curing could expand a tiny amount of air between little gaps, appearing as bubbles.

■環氧樹脂可能會使琺瑯塗料溶解。在將大量的樹脂液倒入時，硝基系的塗料亦可能會因溫度上升而有溶出的現象，須多加留意。欲進行水沒作業時，要先在硝基系的表面加上厚厚的保護層，或是將環氧樹脂液用筆刷塗在表面做保護塗層，再進行倒入樹脂液的水沒作業。

Epoxy resin will easily eat through and dissolve enamel paints. When submerging buildings and objects colored with enamel paints, make sure to coat them with clear lacquer paint. You could also cover the models by brushing on a thin layer of clear resin.

■用土壤做成地面或是使用紙黏土等含有較多水分的素材時，要徹底乾燥過後再倒入樹脂液。否則可能會因爲樹脂液與水分起反應而產生氣泡。

When using paper/wooden clay, or other materials containing moisture to create your diorama's ground, give them enough time to dry before pouring the resin. Air bubbles may appear due to resin reacting with moisture trapped in the groundwork.

■若是在樹脂裡封入含水分的物體，如食物、昆蟲的屍體等，可能會在樹脂硬化後內部發生腐敗的現象，所以除了完全乾燥的物體之外，盡可能別將這些物體放進樹脂裡。

If you submerge food or insect carcasses that still contain moisture, they may decompose inside the resin after a certain period of time. Make sure every object you plan on submerging under resin is thoroughly dried.

製作模板時

Assembly of the molding frame.

■樹脂液流動性高，容易漏出，請務必再三確認要倒入的場所（模板）是否有縫隙。

Resin will find any poorly sealed gap and seep through, causing a disaster. Take extra care to make sure there are no gaps in the mold.

■若使用聚丙烯（PP）或矽膠材質的模板，樹脂便不會有咬住模具內壁取不下來的狀況，但如果使用這兩種之外的材質作爲模板，例如俗稱塑料板的聚苯乙烯板或壓克力板的話，接觸到樹脂液的部分會被侵蝕，導致無法將其分離，因此建議要先在模板的表面噴上矽膠防護層之類的離型劑。

Polypropylene sheets are recommended when building a molding frame; however, if you decide on using different materials such as plastic or acrylic, don't forget to apply a thick coat of mold release agent before pouring in the resin.

在倒進樹脂液之前

Prior the resin pour.

■樹脂屬於化學藥品，使用前一定要閱讀隨產品附上的說明書。注意環境保持通風，小心不要使其接觸到皮膚。有時仍會有因失誤而滲漏溢出的狀況，爲了減少傷害，請一定要在托盤之類的物品上進行作業。

Resin is a highly toxic chemical, so be sure to carefully read the accompanying instructions before use. Ventilate your room, and avoid direct skin contact with resin. Work on top of a large tray to minimize damage to tables and floors in the event of a leak or spillage.

■大量倒入樹脂液時，會因硬化時發生的化學反應而產生較高的溫度。有時塑膠模型會在沉入樹脂液時因高熱而變形或是融化。所以請不要一次大量倒入樹脂液，而是分好幾次倒入。有時覺得一次只倒大約 300 克到 600 克，應該沒問題吧，卻還是因爲當時氣溫較高或倒入後的液面高度較高，而發生高熱的狀況。

Pouring large quantities of resin will generate heat caused by the chemical reaction. This could damage plastic buildings or any other objects with low heat tolerance. Avoid pouring resin in large quantities all at once. Resin pours divided into 300 to 600g per pour are recommended, though this depends on the type of resin you are using and the size and complexity of the diorama you are building.

■在追加倒入樹脂液時，要先等之前倒入的部分冷却至一定程度後，才可接著倒入。一次倒進大量樹脂液的話，依照當下的條件狀況，有時溫度會接近攝氏 200 度，要小心不要被燙傷了。一旦產生高溫，樹脂液內部會有沸騰現象，可能造成許多細小的氣泡或黃變，所以務必要留意溫度的掌控。

When pouring the next resin layer, allow the first layer to cool down to a certain degree. The temperature of the resin could reach as high as 200 celsius, so be careful not to burn yourself. High temperatures could also cause micro-bubbles to form and potentially alter the resin's characteristics, resulting in yellowing in a short time.

■不想被樹脂液沾到的部分，要事先用紙膠帶貼住或用塑膠袋包住。在倒入樹脂液時，樹脂液的流動偶爾會被靜電影響而發生偏移，導致沾到預期以外的地方。

Cover the areas where you do not want the resin to adhere by masking them with tape or plastic bags. The resin could pull itself in an unexpected area by surface tension or static electricity.

在倒進樹脂液時

During the resin pour.

■著色時要使用透明的琺瑯塗料。注意千萬不要加太多，否則樹脂會變得不透明，好不容易做好的成品卻

變得看不清楚了。作者本人的經驗是每 150 克的樹脂液裡，大約加 3 滴左右的琺瑯透明顏料。

Use clear enamel paint for coloring the resin. Be careful not to add too much paint, as the resin will easily become opaque, making it difficult to see what you have painstakingly created and submerged. Masaki typically adds three drops of paint per 150g of resin.

■若沒有仔細將樹脂液攪拌均勻，就會硬化不良，導致有些地方無法變硬。在做攪拌混合時，就算樹脂液是透明的，也能看到液體形成的條紋，只要還看得到液體條紋，就是攪拌得還不夠均勻。

Mix the resin (the primary solution and the hardener agent) thoroughly. When you can still see faint streaks of lines in your resin, you haven't stirred it well enough.

■大量使用樹脂液時較容易發生中間凹陷的狀況。倒入的量越多，硬化的速度也會隨之上升。（依照場合的不同，有時只要數十分鐘便會硬化）

Large pour could cause sink marks to occur. The greater the volume of the pour, the faster the curing speed. In some cases, the resin will cure in tens of minutes.

■在夏季氣溫較高的場合下，硬化速度也會增快，發熱也會增加，需特別注意。雖然依不同的品牌而有所差異，但一般最適合操作樹脂液的室內溫度是攝氏 23 度左右。若想使其慢慢硬化，讓環境溫度稍微降低一點也沒有關係。

Please remember that the resin poured during the summertime will increase its hardening time and the heat generated by its chemical reaction. A room temperature of around 23 celsius is likely optimal for most two-component resins.

■冬天時樹脂液的黏稠度也會上升，氣泡會變得較難自然消失，這時只要使作品或樹脂液的溫度提高，氣泡就會容易消除。若想提高樹脂液或作品的溫度時，可以利用泡熱水或是放在電熱毯上的方式加熱，作者則是使用吹風機加熱。在使用這些工具之前，務必要事先確認使用的方法。

The viscosity of the resin increases during the winter, making it more difficult for air bubbles to escape. Masaki uses a hair dryer to heat the resin as well as the diorama.

■一開始先讓樹脂液在最底部的地面處先流佈薄薄一層，使其硬化後再繼續倒入樹脂液，這樣可以防止預期之外的氣泡產生。利用紙黏土等材料做部件時，很容易從黏土冒出很細小的氣泡，所以最好先進行上述的預防工作。

When pouring resin in multiple layers, it is best to let the initial layer cure fully to trap any air bubbles that might form from the base. This step is essential, especially if you use paper or wood clay for your groundwork.

■攪拌樹脂液後，將其倒入模板時，千萬不要將沾附在攪拌容器內壁上的樹脂液，也用攪拌棒刮一刮、倒進模板裡。模具內壁周圍的樹脂液常常是最不容易被攪拌均勻的，容易造成硬化不良。

Avoid scraping off the remaining resin from the cup (or whatever container you used to mix the resin). Typically such excess resin is not well mixed, which could cause insufficient curing and other problems.

■在等待硬化時，也要盡可能地一邊檢查，一邊確認是不是有氣泡冒出，若有氣泡冒出，要仔細地一點點刺破消除或撈掉。時常會發生以爲已經沒問題了，而把目光移去他處作業，但氣泡卻在這時又冒出來的狀況，要多留意。

Check for air bubbles as much as possible during the curing process. If bubbles appear, squash or scoop them out frequently.

將模板移除時

Removing your diorama from the mold

■有時乍看已經硬化了，但其實沒有完全硬化。即使已經超過說明書上表示所需的硬化時間，也要用牙籤之類的工具用力戳戳看，完全不會被刺出凹洞時，就是完全硬化了。

Even if the resin appears to be cured at first glance, it may not be completely hardened. Make sure you wait until the hardening time specified in the instruction sheet. Poke the top surface of the resin with a toothpick or the like. If no dent appears, your diorama is ready to be removed from the mold.

■若在完全硬化前，就試圖將模板移除，有時會造成模板無法順利剝離，導致只有已經硬化的部分能脫離，使表面變得凹凸不平。

If you try to remove the diorama from the mold before the resin is fully cured, it could cause part of the resin to flake off, resulting in ugly bumps.

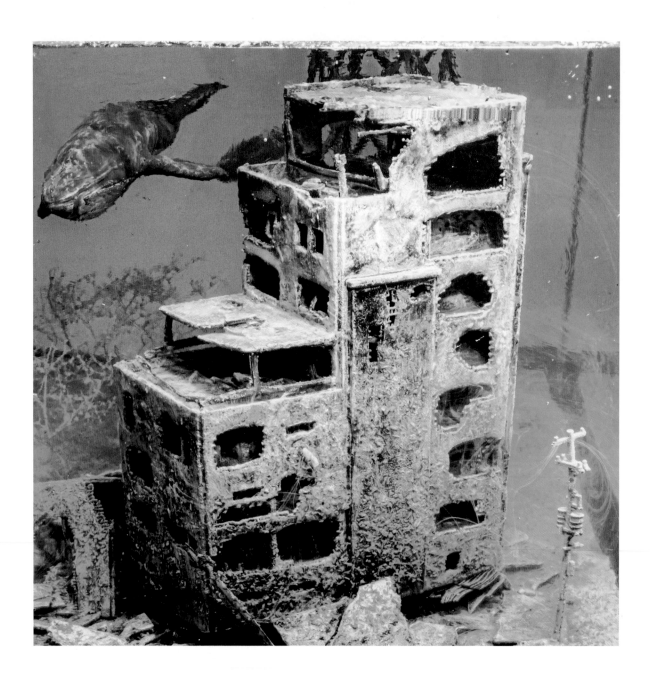

Quiet Sea

File_001

寧靜之海

□ 2022 年製作
□ W:235 ㎜ × D:180 ㎜ × H:280 ㎜

沉入水中的廢墟，毫無人類的跡象，在這寂寥的水沒都市裡，只見鯨魚正悠然地游泳於其間，本作品便是依照這樣的構圖製作而成的。沉入水中的建物外壁已崩塌墜落，可以看見建築內部的瓦礫和家具，感受到曾經有人在此生活過的痕跡。鯨魚周遭呈現漩渦狀的水流、太陽光照射進海洋中的環境氛圍等，都讓這個反烏托邦的世界，更添神秘感。巨大高聳的鐵塔是用 3D 列印製作的。因為是比較大型的作品，所以必須要一邊全心全力注意不能使其破損，一邊進行製作作業。

There is no sign of people in the sunken ruins, and the construction mainly shows a whale swimming leisurely in a lonely submerged city. The exterior walls of the submerged building collapse, and rubble and furniture can be seen inside, showing signs of people's past presence. The swirling motion of the water around the whale and the underwater atmosphere when sunlight shines in give this dystopian world an air of mystery. The tall steel tower was built by 3D printing. Because it was a relatively large work, it was produced with the utmost caution against damage.

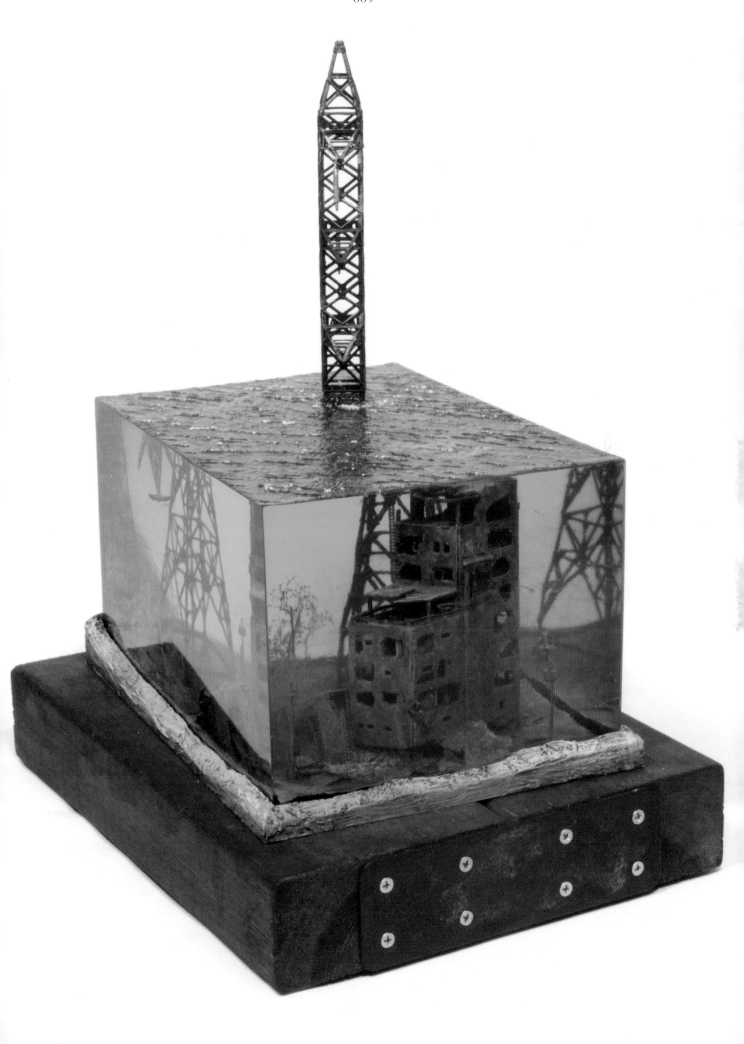

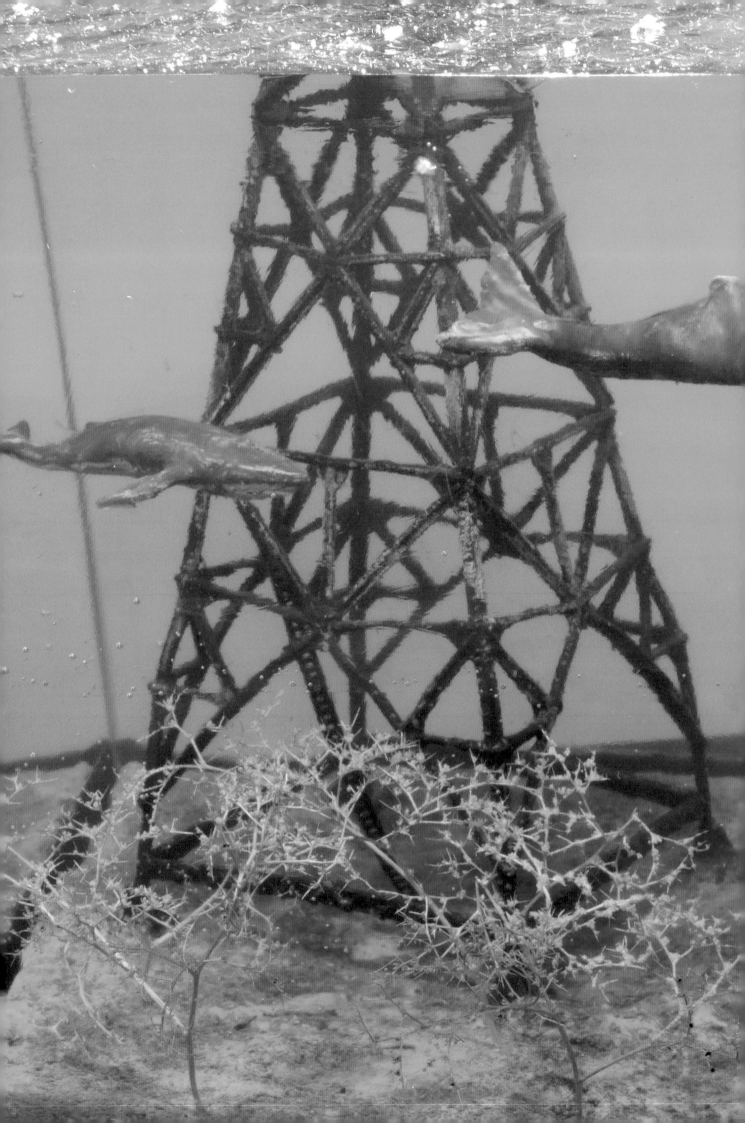

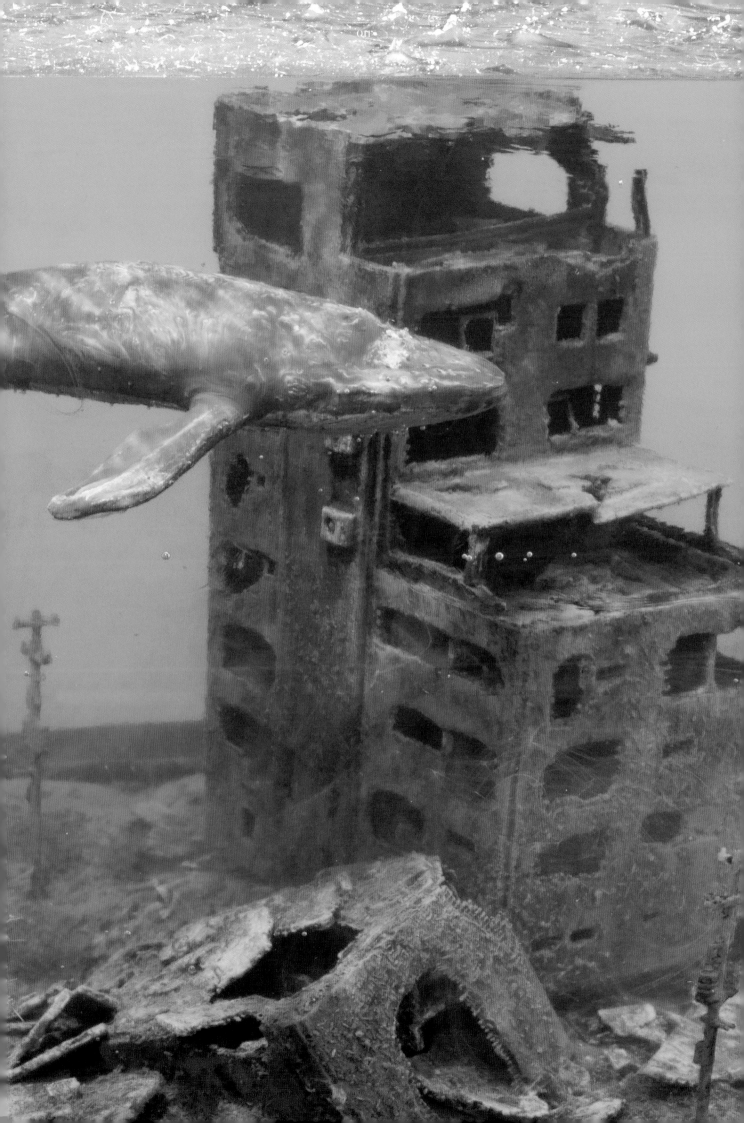

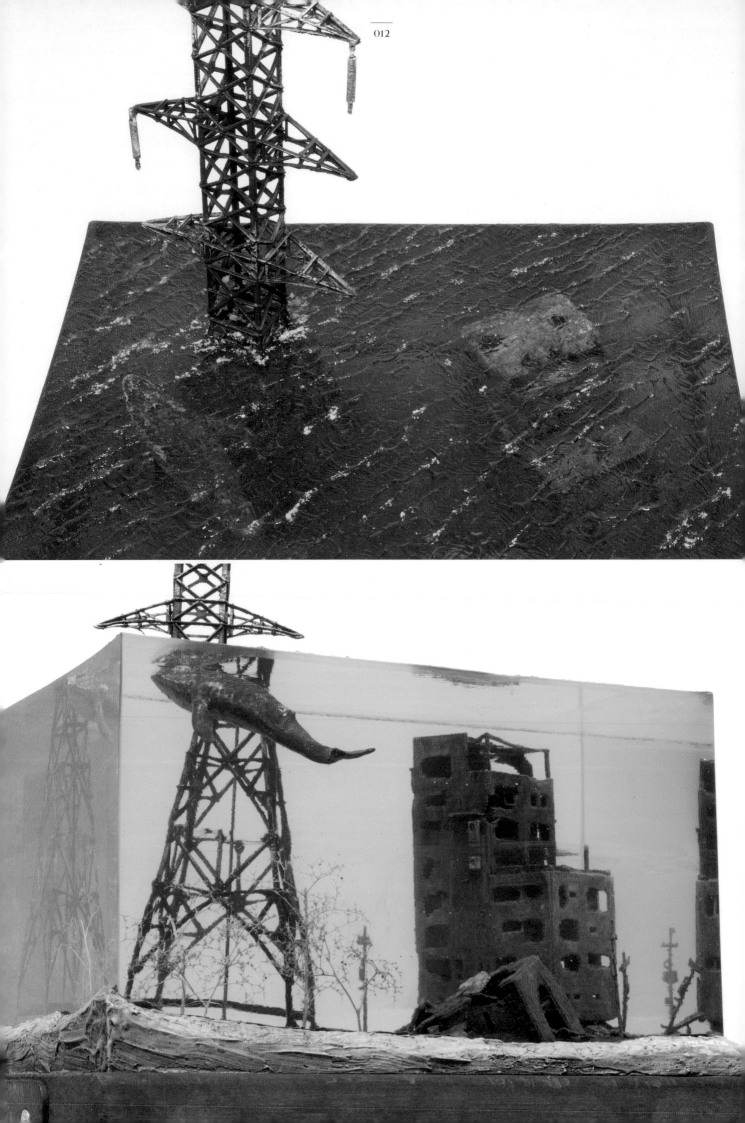

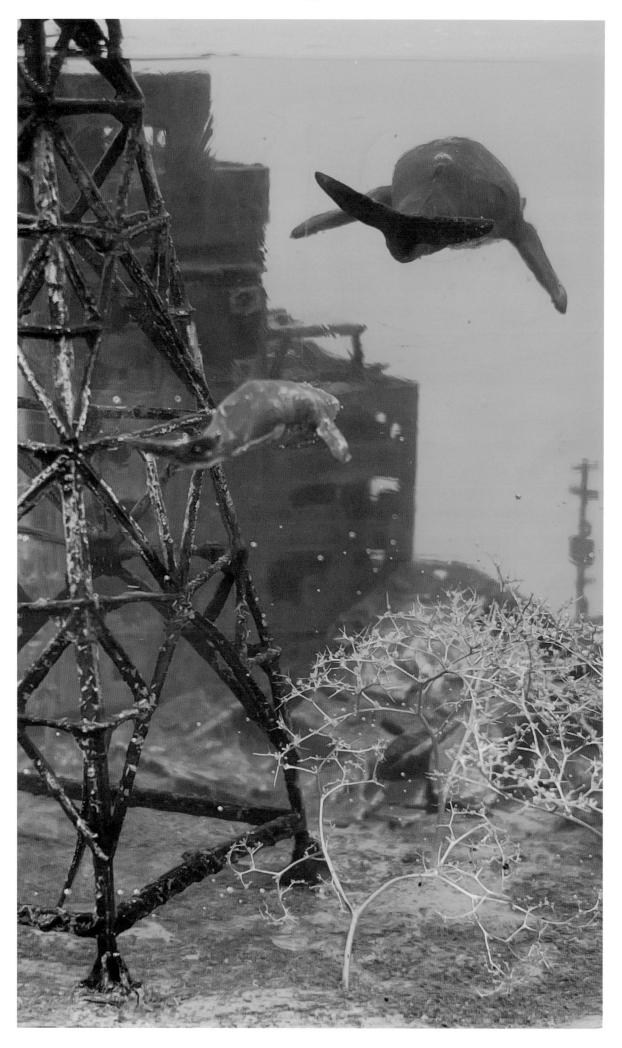

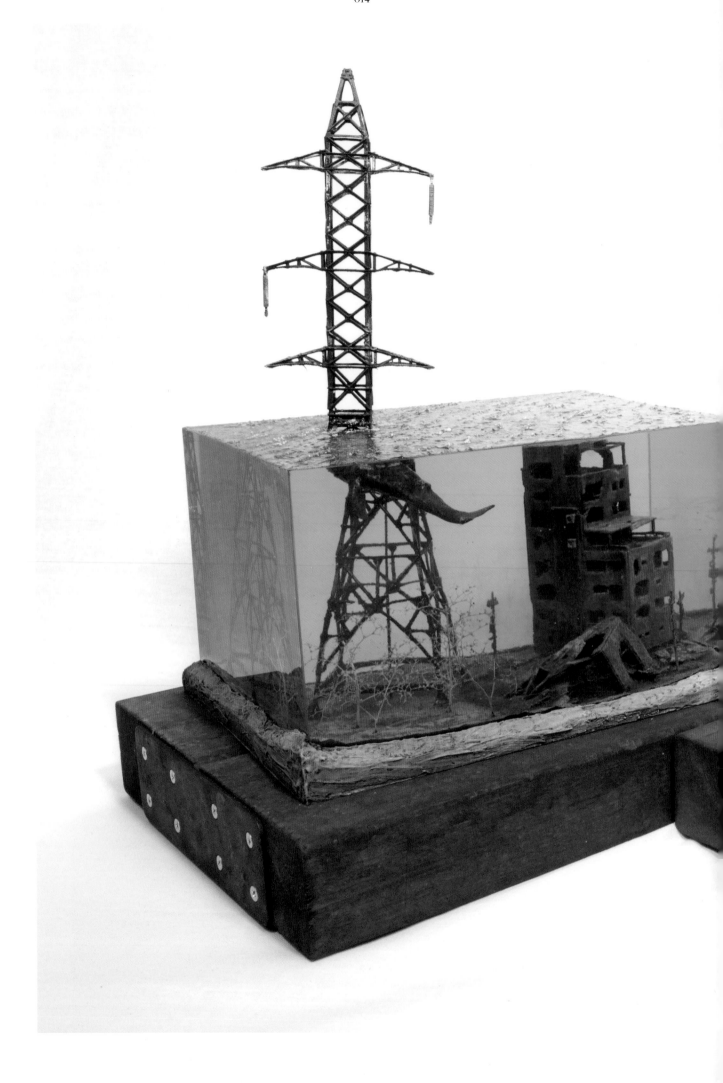

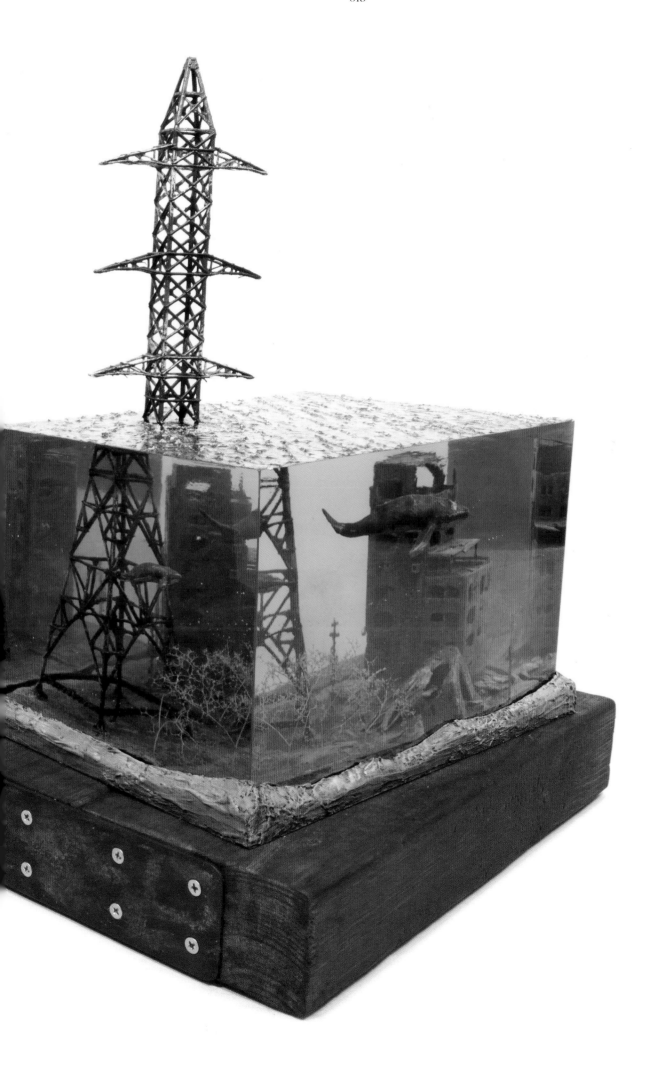

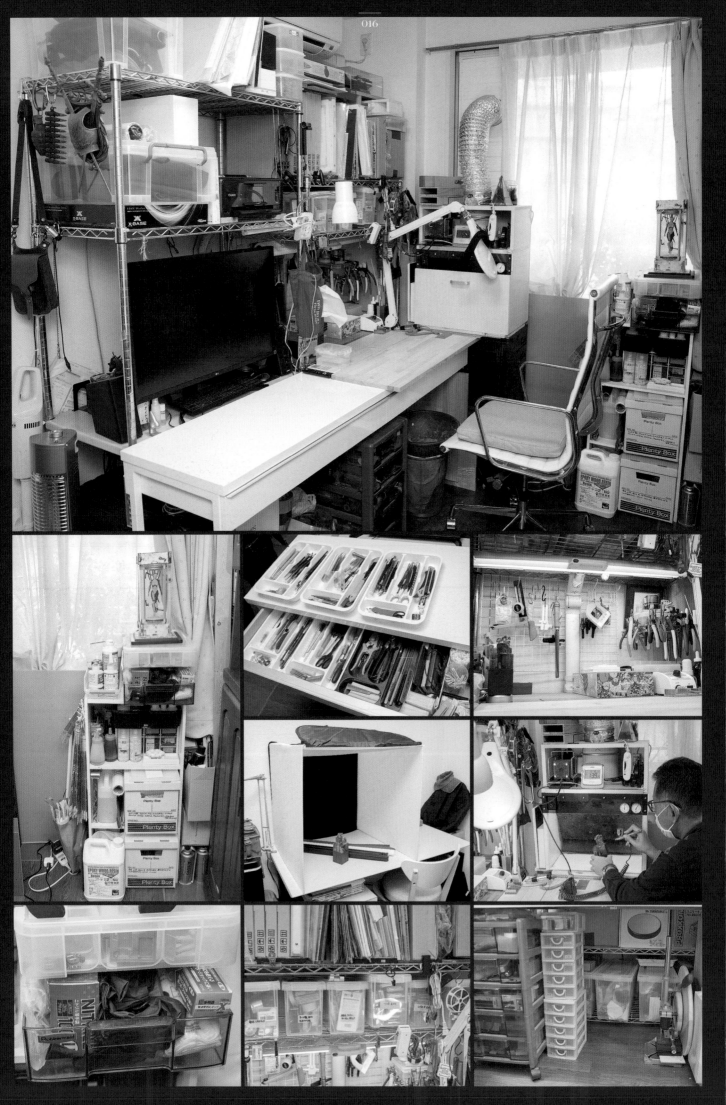

MASAKI'S ROOM

究竟是用了什麼樣的道具，才能產生出擁有獨一無二世界觀的作品呢？
在此除了介紹作者使用的工具，也要將成為靈感的各種素材、充滿個性的創意點子，一次全部大公開。

What kind of items do they use to create their unique and one-of-a-kind works of art?
Here, we will show you not only the tools used, but also the materials used and unique ideas.

意外地製作專用的房間並沒有很大。但是潛藏於此的創意數量卻非常的龐大，因為這個製作空間，是藉由 MASAKI 流的收納整理術之賜而建立起來的空間。製作用的桌子是將兩張桌子並排後，又往前後擴張了兩張桌子。主要的製作桌，放的是跟製作工藝相關的物品，輔助桌則是放置桌上型電腦。桌子的右側位於窗邊設置一個常設型的塗裝箱，這是為了能隨時將作品移過去做塗裝作業。各種不同材質的製作材料，則是依題材的不同分類，保管在製作用桌的櫃子及背面那一側的收納箱裡。只要活用塑膠製的密閉容器，就能妥善管理龐大數量的製作用材料，也能在想用的時候立刻拿出來使用。

The workroom is surprisingly not that large. However, the number of items stored there is very large, and MASAKI's storage and organization techniques shine through in the work space. Two work desks are placed side by side, and the front and rear desks are also extended. The main work desk is mainly used for craft-related items, and the sub desk is used for a computer. A painting booth is permanently set up near the window so that visitors can easily move to the painting process by looking to the immediate right. Material-related items are categorized by genre and stored on the shelves of the work desk and in storage placed on the rear side of the desk. The use of airtight plastic containers allows the vast number of materials to be managed and accessed immediately when the user wants to use them.

MASAKI's favorite products

水相關的製作材料

無論如何都絕對不可或缺的，就是重現各種「水」之質感的製作材料。除了最關鍵的環氧樹脂，也收集了各式各樣的媒材。在製作鐵路模型時會用到的粉狀材料也是必備材料之一。

The essential materials for reproducing water effects. Epoxy-based resins, and various types of mediums are included.

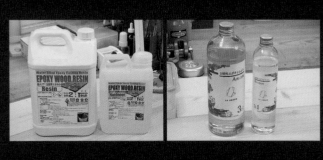

Plants

植物素材

製作 AFV 或鐵路模型時會用到的情境材料或靜電植毛工具也都全部備齊。每種素材都依照顏色或類型，以塑膠容器分門別類各自盛裝，再以必要時能立刻取出的方式收納存放。

Scenery materials for railway modeling are used. Those are sorted by color and type and stowed away for quick retrieval when needed.

Display bases

基底相關材料

基底部負責支撐整件作品，是不能忽視的存在。利用各種木材的著色劑或木紋貼紙，來增加完成時的高級感，也能增加水沒場景模型的完成度。

He pays attention to the display base that complements work. A variety of wood coloring materials and wood grain sheets make the work feel more luxurious.

Various other materials
各種廢品素材

平時並不會預先決定要使用哪類素材，而是從各種不同的觀察角度來收集日後可能派得上用場的材料。若是有合乎作品印象的素材，不管它原本是什麼東西的其中一個部件，都能拿來活用，這就是 MASAKI 流的模型製作方式。

He collects materials that can be used from every angle. As long as the material suits the image, the MASAKI style of modeling makes use of whatever parts are originally used.

 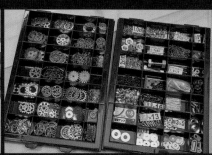
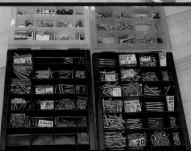

Tools
製作工具

配合個人的製作習慣，備有自製的塗裝箱、集塵機等工具。將工具以方便取用的原則，放置於主要的製作用桌上（請參考前一單元的照片）。在倒入樹脂液時，負責防止漏液的 PP 板也是必備工具之一。依照使用時的尺寸，預先切割後，再大量的存放備用。

He prepares his own painting base, dust collector and other necessary items according to the style of the build. Each item is arranged in a way that is easy to handle.(See the picture in the previous page.)

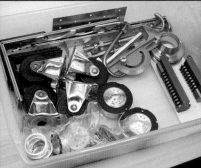 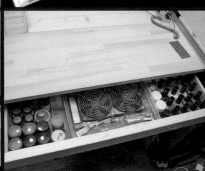

How do you build a "Submerged Diorama?"

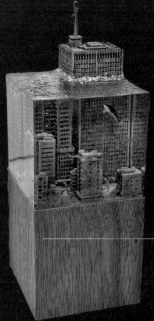

水沒場景模型的完整製作流程

讓我們跟著 MASAKI 一起來看水沒場景模型的基本製作流程吧！
建議先詳細閱讀第 5 頁所刊載的注意事項後，再一起實踐製作。
先從小型尺寸開始挑戰吧！

Let's go over Masaki's method of building a submerged diorama.

Things to prepare
事先準備物品

■ 想沉入樹脂液內的模組或塑膠模型等　■ 各種塗料　■ 2mm 厚的 PP (聚丙烯) 板　■ 保護膠帶
■ 黏著劑　■ 樹脂液　■ 熱風吹風機或熱風槍等　■ 銼刀或美工刀
■ 壓克力無酸樹脂凝膠 (GEL MEDIUM)　■ 表現水泡用的材料　■ 可作爲場景模型底座的木質厚板材料

Various paints - PP (polypropylene) sheets 2 mm thick, etc. - Masking tape - Adhesives - Resin solution - Hair dryers, heat guns, etc. - Files and cutters - Gel medium and foam expression materials - Wood blocks and other items used for diorama bases

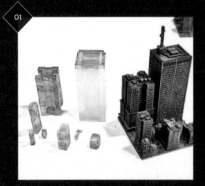

01. 首先，要將欲沉入水中的建築物或機甲等模型事先做好。想用 3D 列印或是市售的塑膠模型也都沒有問題。

First, we must prepare buildings, mechs, or anything else you want them to submerge into your diorama. You can purchase a suitable plastic model kit or print them using a 3D printer.

02. 若建築物內部或機甲本身內部爲中空的場合，沉入樹脂液後，積存在內部的空氣常會不受控制地被推擠出來，所以就算是看不到的地方，也要盡全力將隙縫全部封住或填滿。

If the building or mechs you plan to submerge are hollow, you must fill them so air won't be trapped inside when pouring clear resin. Make sure you protect your entire model with a clear lacquer coat.

03. 若表面使用的是琺瑯系的塗料，最好要噴上一層厚厚的透明保護漆。

If you used enamel paint to paint your model, applying a thick coat of clear lacquer is a good idea.

04. 地面製作完畢後，再將建築物一一配置。在製作地面時，若使用紙黏土或木粉黏土製作的話，黏土內部很容易殘留水分或空氣，要特別注意。

After creating the ground base, place your buildings and mechs. If you use paper or wood clay, give them time to dry completely.

05. 製作模板。用來做模板的材料是在價格均一商店就可買到的 2mm 厚 PP (聚丙烯) 板。聚丙烯的耐化學藥品能力相當高，擁有瞬間接著劑或環氧樹脂接著劑也無法黏附於其上的特質，所以不太容易發生樹脂黏附而導致無法脫膜的狀況。

Masaki uses 2mm thick polypropylene (PP) sheets to produce a molding frame. Resin and most adhesives will not stick to the surface of PP sheets.

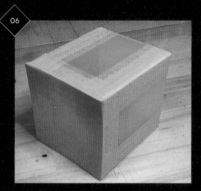

06. 補強作業要做得確實。若用壓克力板或塑膠板來做模板，在倒入樹脂液之前，就必須在模板的表面事先噴上一層 MR.SILICONE BARRIER 之類的矽膠離型劑。

Reenforce the molding frame using masking tape. If you use acrylic or plastic sheets instead of PP sheets, apply a mold release agent before pouring the resin.

07. 將場景模型配置於模板裡。在設置場景模型的時候，建議使用施敏打硬的 SUPER X 的黏著膠或 Bond's 的 ULTRA 多用途 SU 接著劑，將模型固定於模板的底部。場景模型部分若有使用到木材、保麗龍、木粉黏土等材料，在倒入樹脂液時會因浮力而浮上來，所以建議要使用強力的黏著劑來固定。

Glue the diorama to the base of the molding frame using an adhesive such as Cemedine's Super X or Bond's Ultra Multi-Purpose SU. This should prevent the diorama from floating when the resin is poured.

08. 將樹脂液倒進去。若一次倒進大量的樹脂液，硬化時會因化學反應產生的高溫而發熱。如果放入的是不耐熱的塑膠材料模型，就會因硬化時的高熱而使塑膠融化變形。因此，若要將塑膠製的部件沉入樹脂液中，請分成數次、少量倒入樹脂液。

Resin generates heat due to the chemical reaction as it hardens. The heat could damage your diorama, especially if made of plastic. To avoid this, pour your resin in multiple batches.

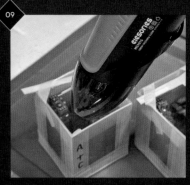

09. 通常在作業過程中，將樹脂液倒進模板時，每次倒入一層約 1～2 公分左右的高度，等這一層硬化到一定程度，熱度也變涼了之後，才會倒入同樣高度的下一層。倒進樹脂液後要將表面的氣泡一一消除。這道手續是每次倒入一層樹脂液，就要仔細地進行一次。尤其是樹脂液表面以及模板交界處的氣泡，一定要全部消除。

Masaki pours his first layer of clear resin until it reaches roughly 1~2cm in thickness. Once the initial layer has hardened to some extent, and the hear has cooled, he pours in the second batch. Squash any air bubbles that appear on the surface of the poured resin.

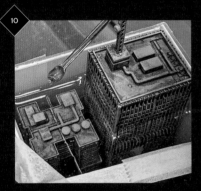

10. 樹脂液全部倒入後，靜置待其完全硬化。要使其完全硬化，室溫的狀況下至少要靜置 24～48 小時左右。

Wait for the resin to cure completely.

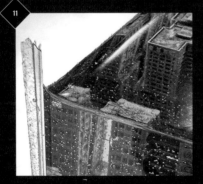

11. 將模板拆卸剝離去，修整一下因表面張力而向上延伸的四個角落以及四個邊邊的突起毛邊。

Disassemble the molding frame and carefully trim the surrounding edges of burrs and excess resin.

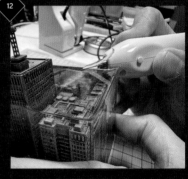

12. 完全硬化後的樹脂相當堅硬，所以作者處理時用的是超音波電動美工刀。修整後再用銼刀將表面磨平，再慢慢將磨砂紙越換越細，磨到修整處完全變成透明為止。

Masaki uses an ultrasonic cutter since fully cured resin is quite hard. After trimming, flatten the surface with a file and polish it till the transparency of the resin is regained.

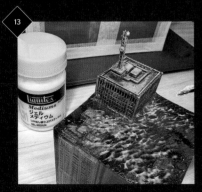

13. 開始製作水面上的波浪。波浪的部分，是使用無酸樹脂 GEL 凝膠劑來堆疊出浪花的形狀。要是塗得太厚，就要花比較長的時間才能完全乾燥，所以務必要注意不要一次塗得太厚。

Waves are created using a gel medium from Liquitex. Be careful not to apply too thickly at once, as it will take much longer to dry and become transparent.

14. 建築物這類從海面突出的部分，會跟海面之間產生波浪撞擊的泡沫，若想追加製作泡沫的話，可以將 MORIN 公司的水泡表現素材加進無酸樹脂 GEL 凝膠劑裡，這樣就能重現海浪泡沫的質感了。

To add bubbles caused by waves crashing into objects, use Morin's water bubble expression material mixed with the aforementioned gel medium.

15. 將場景模型和另外製作的底座接合固定。在固定於底座時，容易因為樹脂的重量而使固定的位置發生損壞，所以必須好好思考，如何使其固定得比一般工藝品更加堅固牢靠。

Glue the diorama to a finishing base. The diorama could weigh quite a lot, so take extra care to secure the whole thing firmly with a strong adhesive.

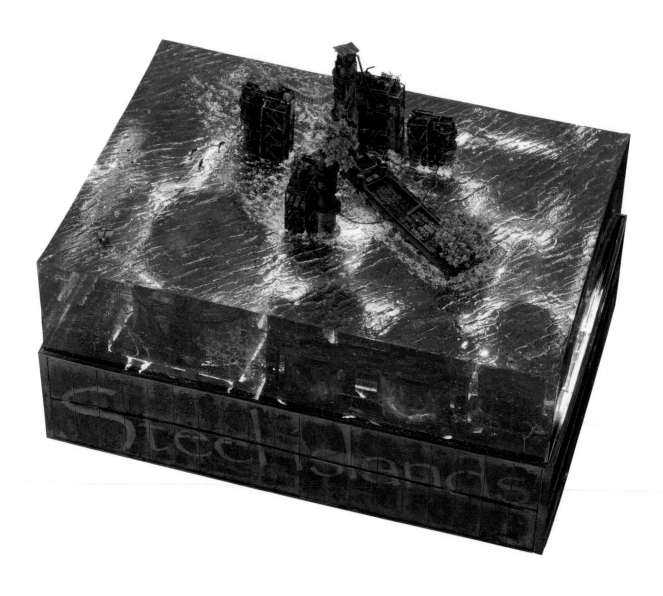

Steel islands

 File_002

鐵之島

□ 2020 年製作
□ W:305 ㎜ × D:215 ㎜ ×H:240 ㎜

劫後餘生的人們，住進了石油煉油廠的遺跡裡，本作品就是從這樣的意境想像中誕生的。僅剩不多的泥土鋪蓋在土砂搬運船上，成爲農地，爲了收集雨水，也在一旁放置水塔。從這些建築物裡，能夠感受到人們在崩壞的世界裡仍拼命努力想要活下來的生命力。在有限的空間裡製作出的煉油廠構造十分繁複綿密，從海中反射出來的七色光芒，也使整體氣氛充滿幻想世界的魅力。一棟棟精心上色的建築、海中的構造物、充滿生活感的村落，使本作品的魅力，筆墨也難以完整形容。

The Diorama's idea is shaped by the image of survivors settling on a former petroleum complex site. A small amount of soil is spread over a sediment carrier and turned into a field, and tanks are also placed to collect rainwater. From these buildings you can feel the breath of those that live hard in a shattered world. The complex is meticulously crafted in a limited space, and the fantastic atmosphere created by the seven colors of light illuminated from the sea is also very attractive.The precisely painted buildings, the underwater structures, the village with a sense of life. It's a work full of charm that can't be written down.

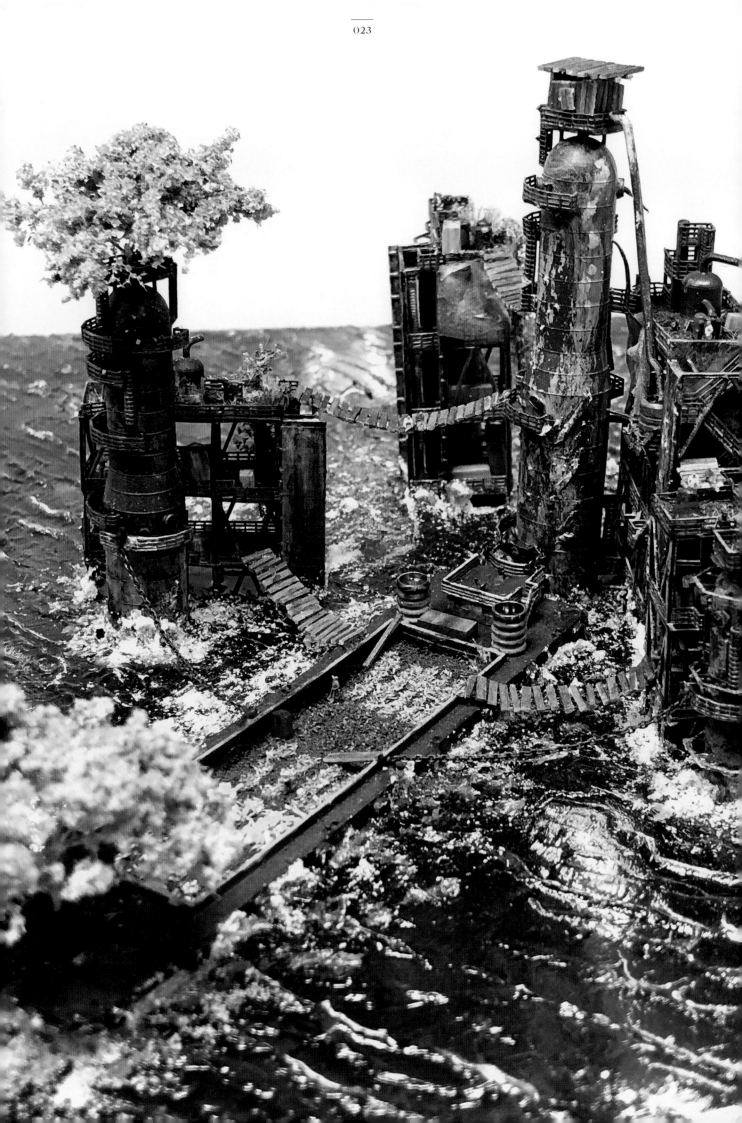

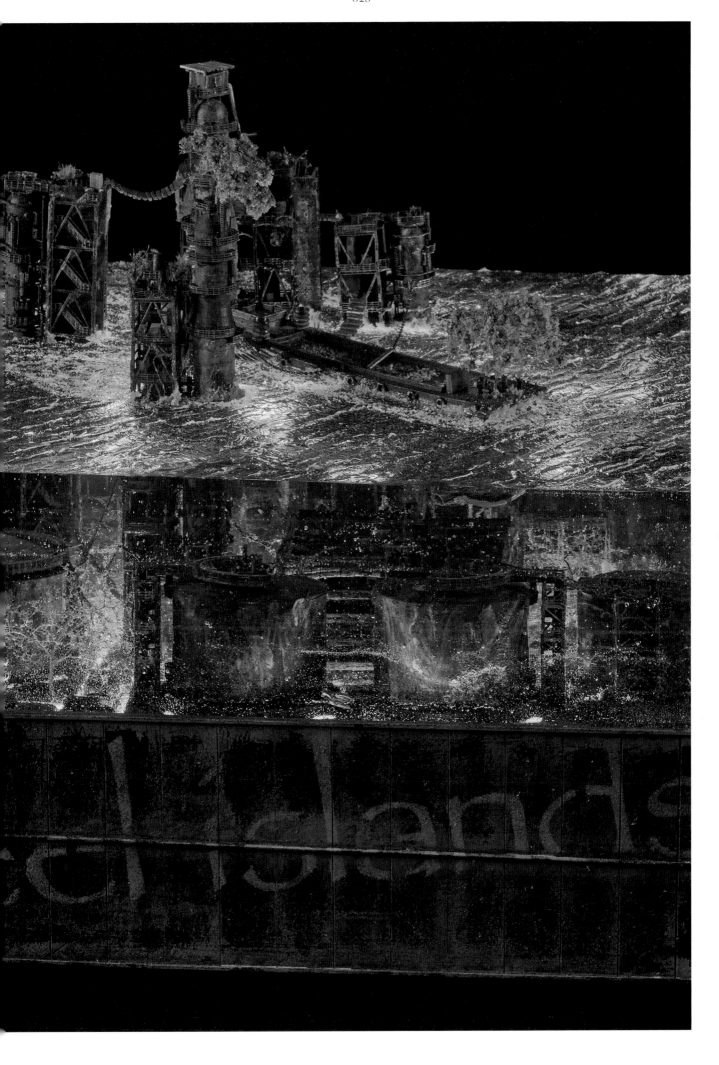

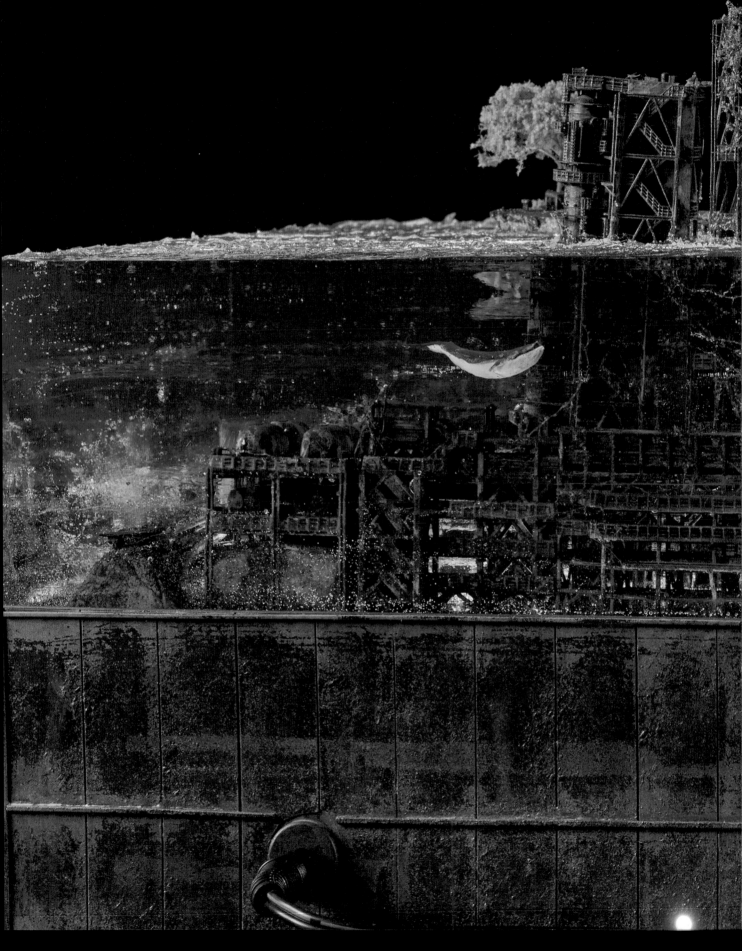

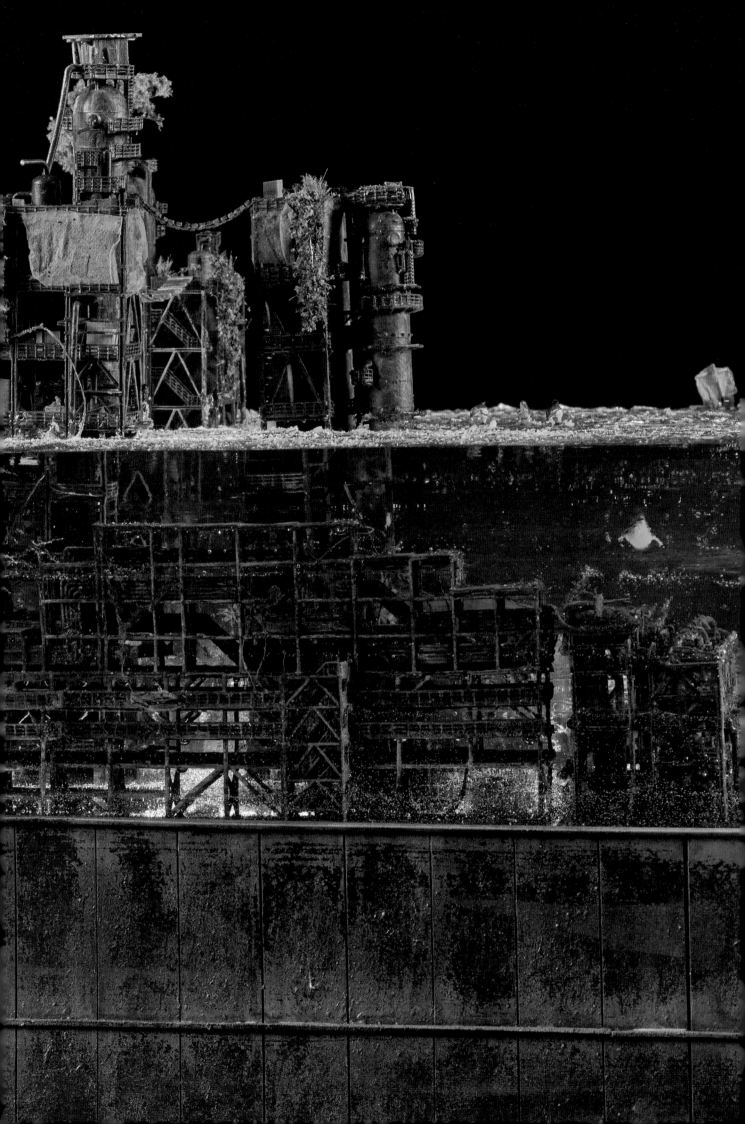

File_002

Steel islands

01. 和建築物相關的部件全部都採用 3D 列印模型。一開始先將其全部塗成黑色，再用 Gaianotes 出品的 U-RUST 鐵鏽色塗料塗佈於整體。像這樣使用黑色先做塗裝打底，才能使燈光照射至模型部件時，光線不會直接穿透過去。

All the buildings and tanks were 3D printed. They were first painted in black, followed by Gaia color's new rust. The initial black layer helps prevents light from seeping through when strong light shines through the model.

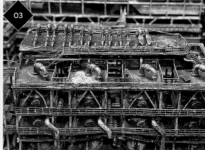

02.03. 在鐵鏽色上噴塗花王 CAPE 定型噴霧 (CAPE SUPER HARD)，再將塗裝色稍微在其塗上薄薄的一層塗膜，呈現出顏色不均勻的模樣。之所以要塗成較薄的塗膜，是為了要方便之後能夠更容易去除並露出底下的鐵鏽色。塗膜乾燥後，拿一枝刷毛較有彈性的筆刷，沾水將定型噴霧上的塗膜刷掉來呈現斑駁狀態。

Apply a coat of hair spray (must be water-soluble) over the buildings painted in rust, then airbrush each building's primary colors. Once the paint has dried, scrub with a brush, soaked in water to chip off the top layer, revealing the underlying rust tones.

04.05. 在預想好尺寸大小的底座上，仔細推敲各種各樣的構圖配置。這個時候要從各種不同的方向角度仔細觀察，並且將實際的水面位置也考慮進去，再進行配置。這次的作品會從底下用 LED 燈打光，所以會一一將每個建築物固定在透明的壓克力板上。

Layout your buildings and other objects on a base. Make sure to view each layout from different angles, and try to picture how the diorama would look once submerged under the water. For this particular build, each building was glued to a transparent acrylic sheet to light it up with LEDs from below.

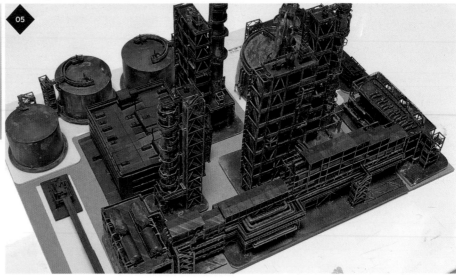

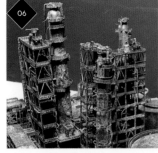

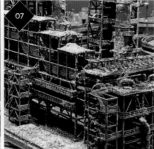

06.07. 保留想讓壓克力板透出光線的部分，其餘地面部分的壓克力板則以黑色塗裝，遮住光線。之後再將地面或建築物的海中部分等部件，用鐵道模型用的土粉及消光無酸樹脂凝膠膠劑做固定。建築物側面有海藻類攀附於其上的部分，則是用綠色系的粉末來上色。

Paint the transparent acrylic sheet (the base) black, leaving only the areas where you want a light to leak through unpainted. The submerged sections of buildings and other objects were covered with green powder to make them look like they were covered with seaweed. The green powder is glued on using a matt medium of special adhesive used for model train dioramas.

08.09. 追加在水沒之前便已生長的樹木，使用的是乾燥不凋花。長期沉沒於水中的樹木，顏色會變得比較發白，所以就不塗裝任何顏色，直接使用。也製作了一些水中的生物，準備沉入水中的部件幾乎都完成了。

Trees and vegetation are added. Masaki uses the "Holland Dry Flower," a common material used by many AFV modelers to simulate vegetation. Some sea creatures were also placed on top of the base.

10. 製作模板，將作品固定在模板的底部。組裝模板時，要讓模板能夠接觸到底板的側面。為了防止漏液，要使用保護膠帶以每層錯開一點點的方式黏貼三層，將模板組裝起來。要小心注意膠帶不要出現皺摺。模板的上部要用木材做固定補強，防止彎曲變形。

Build a molding frame and fix the diorama to the bottom of the mold. Use masking tapes to reinforce each side of the mold to prevent leakage. Be careful not to create creases or warps on the PP sheets (add further reinforcement with a wooden frame if necessary).

11.12. 開始倒入樹脂液。一開始先倒至與地面差不多的深度，待其硬化。這時候就可以預先處理從模板和作品之間的縫隙或是地面粉狀材料之間的空洞冒出來的氣泡。接下來，再將樹脂液分成七次慢慢倒入。在倒入的過程中，依序放入事先做好的生物，就可以做出浮在水中的效果。

Begin pouring the resin. The first layer should be poured just above the ground layer of the diorama. This should stop bubbles from creeping underneath during the following resin pour. The resin is poured in about seven times, with sea creatures placed between each layer to make them seem like they are floating in the water.

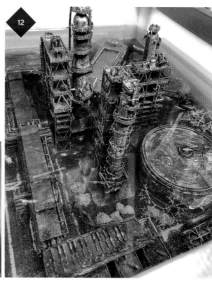

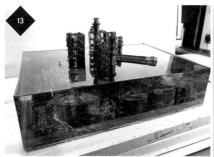

13.14.15. 完全硬化後，將模板卸除，用燈具從底下打亮觀察，確認作品整體的氛圍。在完全硬化之前，若硬要將模板卸除，可能會拉扯到尚未硬化的部分，造成表面的凹凸不平，所以在卸除時一定要有耐心。

Once the resin is fully cured, remove the molding frame. Attempting to remove the molding frame before the ideal curing time could result in disastrous results. Shine a light from below and check the overall atmosphere of the diorama.

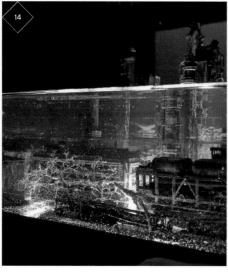

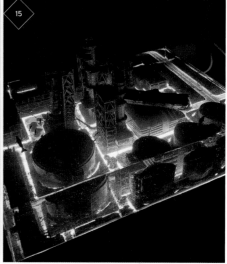

16. 側面最上部的地方因為表面張力而產生微微隆起，所以要將隆起部分切除，再用銼刀打磨的修飾處理。在進行處理前，為了防止銼刀不小心傷到側面，要預先在側面貼上保護用的保護膠帶。銼刀的號數從 120 號漸漸增加到 10000 號，最後再用研磨膏打磨，完成最後的修飾。

Cut and sand the top surface flush. Each corner will have raised resin due to surface tension that needs trimming. Use 120 to 10000 grit sandpaper until transparency is regained. During this process, mask off the vertical sections of the resin to prevent them from scratches.

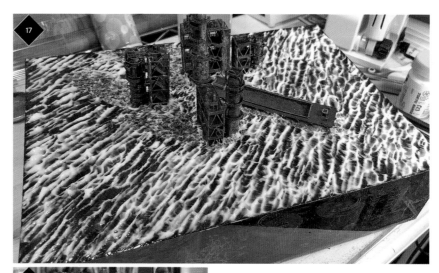

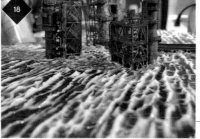

17.18. 使用平頭筆刷和無酸樹脂 GEL 凝膠劑來製作浪花。要是浪花做得太高、太大、太過突出，無酸樹脂 GEL 凝膠劑就只有表面呈現乾燥，內部則會一直呈現白色混濁的狀態，所以浪花高度只做 2～3mm 就好，待凝膠劑乾燥後會變得透明。

Using a flat brush, create waves with a gel medium. The white waves on images 17 and 18 will become transparent as they dry. Avoid making high waves, as this will cause the drying time to extend drastically.

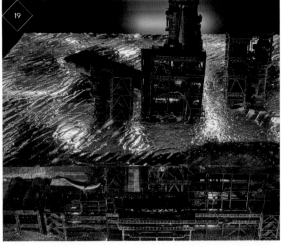

19. 從底下用燈照亮浪花，確認狀況。浪花變透明後會折射光線，看起來就像自然的波浪。

Checking the waves by shining a light from below. You can see that the waves have dried and become transparent.

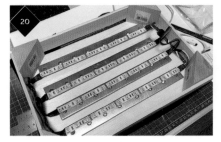

20. 因為樹脂塊非常沉重，所以場景模型的底座要使用木材來組裝，才能足夠穩固。這其中還裝設了市售的LED 燈帶及遙控接收器。為了防止LED 燈帶發熱，箱子也不要整個密封起來，而是將燈帶黏貼於金屬板上以利於散熱。

The base is made of wood with LEDs and light controllers hidden inside. LEDs are lined on top of a metal sheet in order to disperse heat effectively.

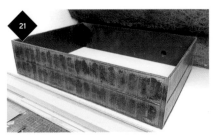

21. 木材基底的模板周圍利用塑膠板做加工，完成了以生鏽工廠外觀為設計意境的底座外壁。電線走線時的孔洞和遙控接收器的紅外線接收處，都要預先留下開孔。

Plastic sheets were glued on the wooden surfaces of the base and painted to resemble a rusted factory exterior wall. Holes for electronic wiring and the infrared receiver are drilled out.

22. 將底座的木框裝上外壁，和場景模型組合後，測試燈具。

The base, the diorama, and the LED units are all assembled and tested before adding the final touches.

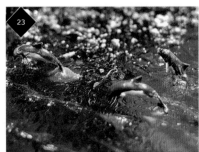
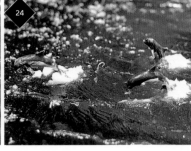

23.24. 將在水面上跳躍的海豚黏起來，並將水泡表現素材和無酸樹脂GEL 凝膠劑混合，加在海豚周圍，用來表現水花飛濺的模樣。

Dolphins were glued in place. The splashes around the dolphins were created using a gel medium mixed with water bubble material (see page 21).

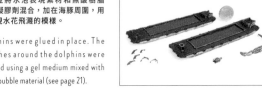

◀ 浮在海面上的土砂搬運船也是用 3D 列印來製作。

These two barges were 3D printed, just like the dolphins.

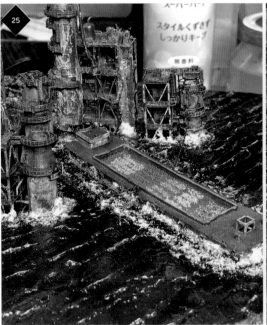
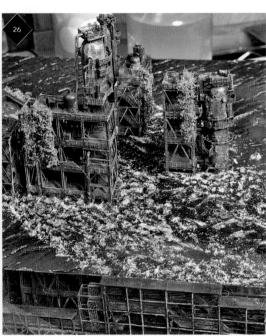

25.26. 和海豚的飛濺水花一樣，在建築物或土砂搬運船的周遭也加上海浪拍打形成的泡沫。一邊考慮風向及浪潮前進的流向，一邊像在描畫船舶航跡般的感覺，並將海浪泡沫一點點地追加上去。

The wakes and bubbles created by the two barges and waves splashing against the buildings were replicated using the same method as explained in steps 23 and 24. Keep in mind the direction of the wind (and waves) when adding these details.

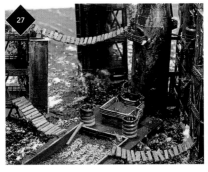

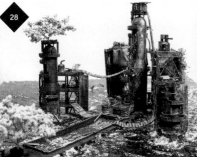

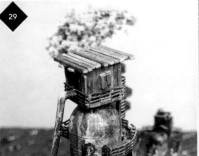

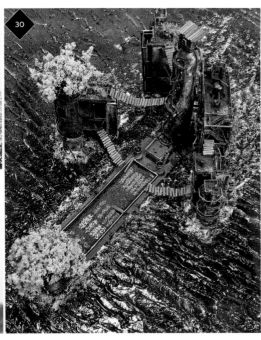

27.28.29.30. 吊橋是用縫衣線黏上薄木片來製作的。塔上的小屋等建築物也是用木材來製作。建築物上用來遮蔽視線而貼上的布，則是用面紙塗抹上薄薄一層消光無酸樹脂凝膠劑所製作的。

The bridges between buildings were made by attaching thinly cut wood slices to a sewing thread. The tarps covering some sections of the buildings are made of tissue aper soaked in thinly diluted matt medium.

31. 在場景中突出於海面的部分，容易讓故事的焦點過度朝向中央部分集中，所以刻意在角落的位置追加了乘坐於木筏上的旅人們，讓觀看者的目光能夠被誘導到更多地方。

Each diorama element, such as the buildings and the people, is too concentrated in the center. Drifters on a raft were added to the edge to balance out the diorama.

32. 製作樹木的時候，先在乾燥不凋花黏上海綿狀的仿真假草，接著再將粉狀假草黏於其上，展現出枝葉繁盛茂密的模樣。

Dutch dried flowers were used as the base for replicating tall trees. Sponge foliage was glued on, and scenic powder was sprinkled on top to blend everything together.

33. 在場景模型的各種地方追加小小的人物。就算很小又只有模糊不清的形象，但只要感覺有人在那裡，就會成爲讓人想像力無限馳騁的要素。

Add people (3D printed) to various parts of the diorama. Although small, these can add a sense of scale to the entire diorama and helps viewers from expanding their imagination.

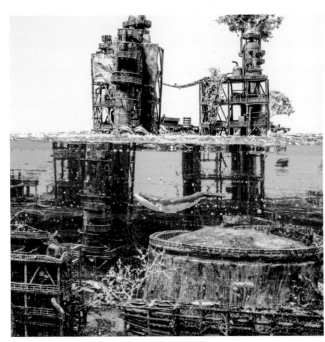

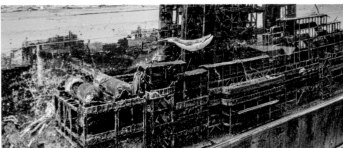

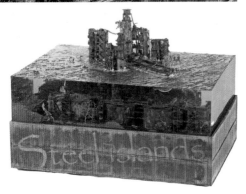

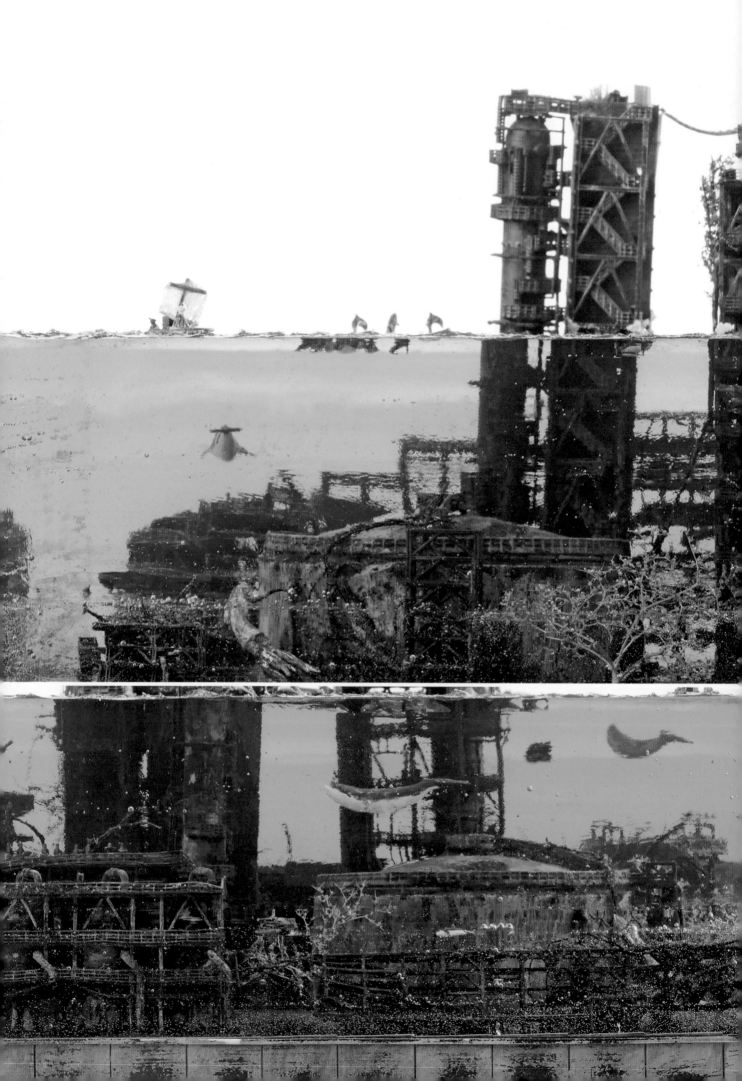

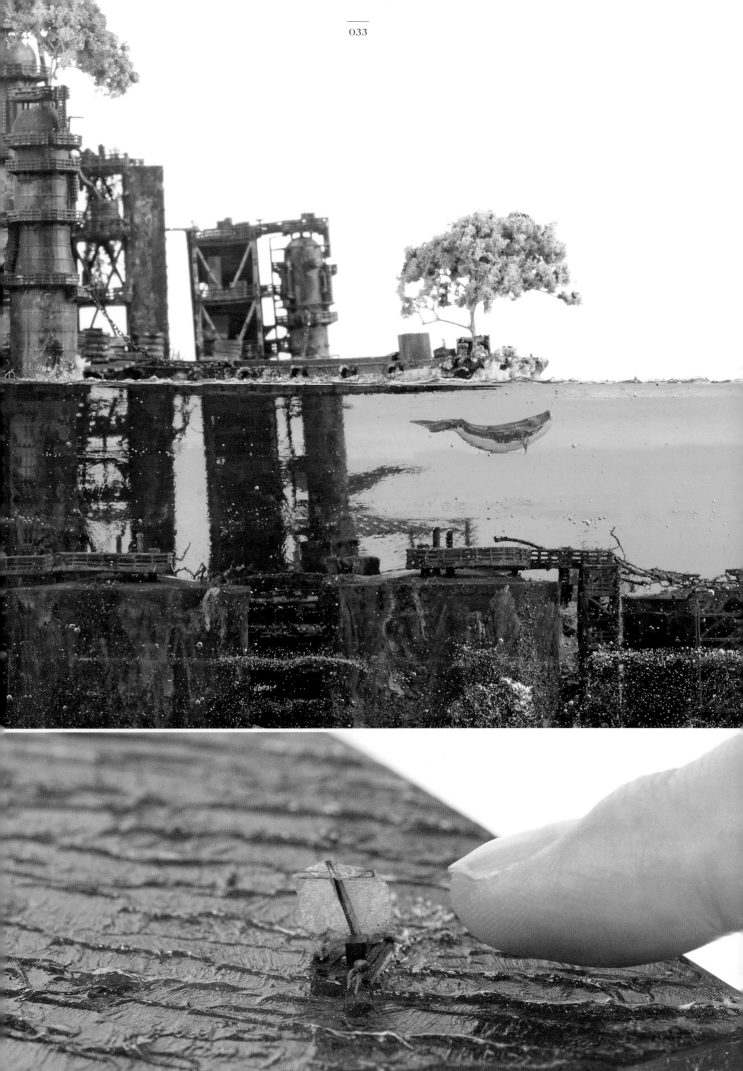

Under the Sea

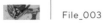 File_003

MASAKI 最初的水沒場景模型作品。以 1/2500 尺寸的 GEOCRAPER 爲基礎，加上海面上的鯨魚、海中暢泳的大王烏賊、大樓上用藍色防水布搭建的帳篷、跳入水中用的跳台、救生艇等精緻巧妙的細節。本作品即爲本書書名的由來。另外這個尺寸也已經成爲現在製作場景模型時的基本形，可說是 MASAKI 作品的起點也不爲過。對於場景模型創作者來說極爲重要的底座部分，也可以看到 MASAKI 對於細節的講究與巧思。

Under the Sea

□ 2015 年製作
□ W:90 mm × D:90 mm × H:150 mm

The first MASAKI's submerged diorama work which includes whales on the sea surface, giant squid swimming on the ocean floor, blue-sheet tents and diving platforms on the building, and lifeboats. 1/25000 scale GEOCRAPER is used for the base. This work is the origin of the title of this book. This size is also the basic form of the current work, and it is no exaggeration to say that this is the start of MASAKI's work. As a diorama builder, the attention to detail also shines through in the pedestal, which is important.

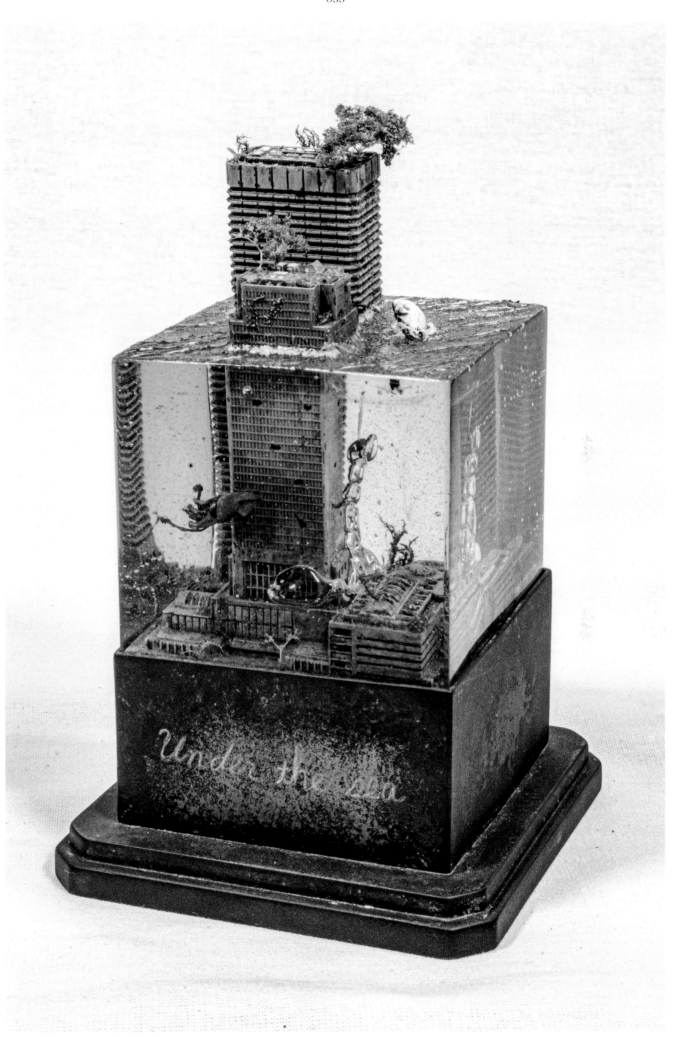

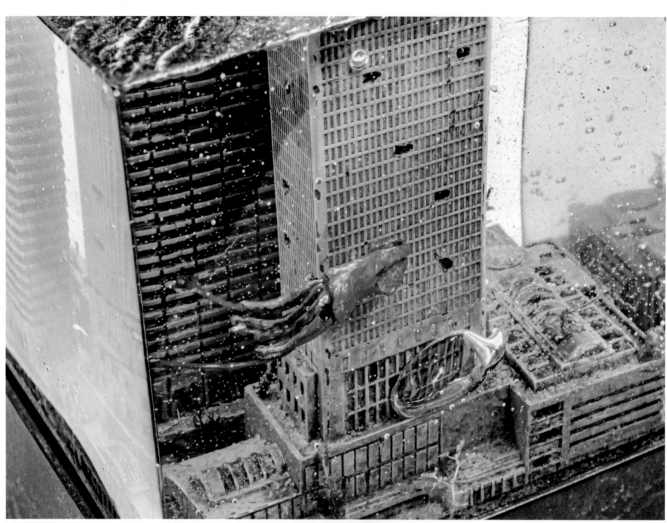

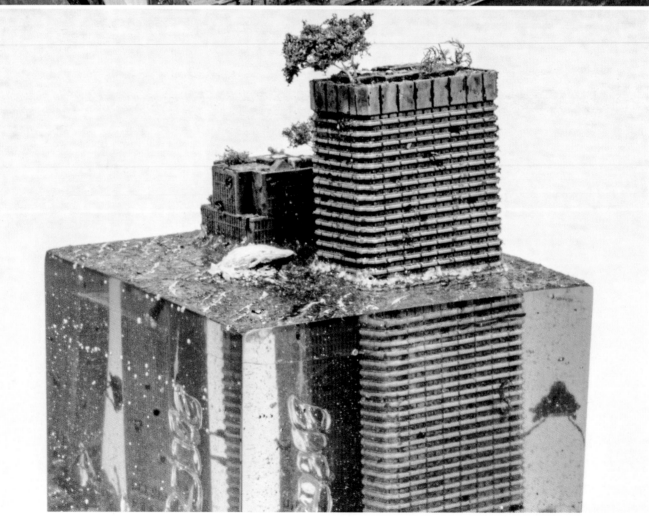

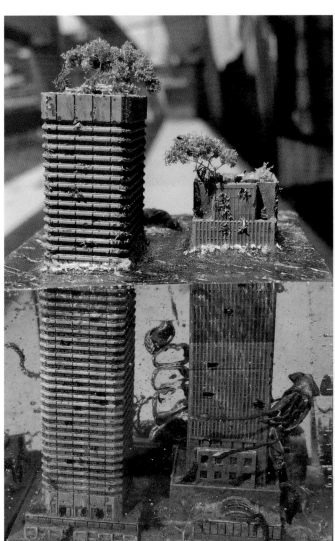

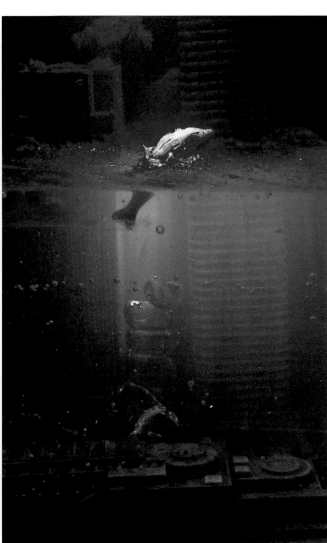

File_003

Under the Sea

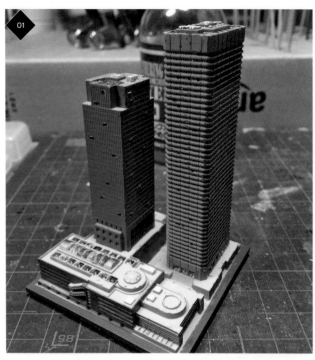

01.Under The Sea 是初次製作的水沒場景模型作品。這時的 GEOCRAPER 只有單色，於是分別在不同的建築物塗上不同的顏色。不過因為是廢墟，為了不讓外觀看起來太過乾淨整潔，所以沒有塗得很均勻漂亮。

This diorama was the very first "submerged diorama" that Masaki built. Each building was painted to add more variety. However, painting them perfectly is unnecessary as they will be weathered extensively in the following steps.

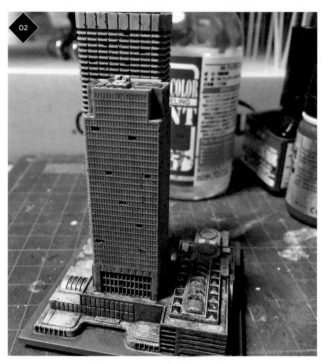

02. 用手持電動磨刻機在數個不同的地方鑽出幾個開口，營造出窗戶玻璃破掉的感覺，也讓牆壁帶有損壞毀傷的感覺。已經上色的部分，使用 Mr. Weathering Color 的 Ground Brown 做漬洗，製造出不均勻的深淺色。

Some windows were opened up with a handheld electronic drill to give them a damaged appearance. Sections of walls were damaged using the same method. The whole building received a coat of Creos Weathering Color's Ground brown. This wash also acts as the base layer of weathering.

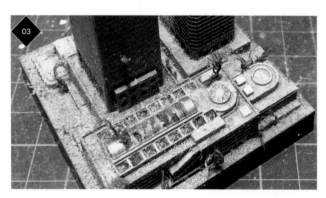

03. 在地面及海底建築物的屋頂上，舖上鐵道模型用的土粉，重現泥砂土石堆積的模樣。在海中的地面各處也植入像海草一樣的植物。

The ground and the rooftops of buildings are covered with a powder material used for the model train diorama. This replicates the sand and dirt deposited under the ocean. Some sea plants and vegetation are placed on the ground as well.

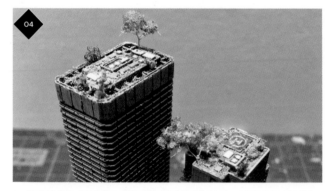

04. 做這個作品時，因為是初次製作，所以在這個階段就已經先在大樓的屋頂上植入樹木或草地了，若仔細考慮後續工程的話，在海面上的這個部分還是留到之後再來加工，應該更能減少加工時的損壞吧！

More vegetation is added on the rooftop of the buildings. Ideally, this step should be done after pouring in the resin. Since this was Masaki's first submerged diorama, he opted to finish the diorama before the resin pour.

05.06. 早期在製作生物類物件時，使用的是環氧樹脂黏土。大王烏賊長長的腳則是用黃銅線做出來的。

Large oceanic creatures such as the whale and the giant squid are sculpted using epoxy putty. The legs of the squid are replicated using a 0.3mm brass wire.

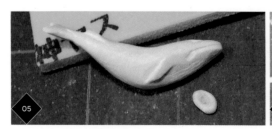

07. 製作模板時，使用的是在價格均一商品店購買的活頁孔夾的封面外殼，因爲想要利用其聚丙烯材質而且是亮面的特性。但是直接使用的話，怕會變形歪掉，所以又用中密度纖維板將其包圍起來固定。

The very first molding frame was made from a binder Masaki purchased at a dollar shop. The covers of the binder had a glossy polypropylene finish. Since the PP covers were flimsy, they were reenforced with MDF.

08. 這時候因爲無知所以毫無畏懼，幾乎是一口氣就將樹脂液倒滿至最上面的地方，幸好運氣不錯，沒有因爲硬化產生的熱度而使部件融化，順利硬化了。在水面處黏上鯨魚，再次追加一點點樹脂液。

The resin was poured in a single, large batch, which is definitely not the recommended way. The whale was added at the top, followed by a final resin pour.

09. 海面是用無酸樹脂 GEL 凝膠劑製作的。在大樓、鯨魚和水面的邊界處，則用混合水泡表現素材的無酸樹脂 GEL 凝膠劑來呈現。

The surface of the sea was created using a gel medium. The edges of the building and the whale were blended in using Moris's bubble material mixed in with gel medium.

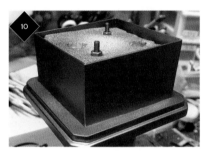

10. 底座使用的是在價格均一商品店購買的透明盒，再將塑膠板製成的箱子組合上去。內部則用 Styrofoam 發泡塑料填滿。先塗裝成黑色，再塗上 Mr. COLOR 的 SUPER IRON，最後用 CLEAR BLUE 塗在部分區塊。

The base of the diorama is made of a clear plastic container. The inside of the base is filled with styrofoam. It was first painted in black, then painted with Mr.Color Super iron & clear blue.

11. 噴上美髮定型噴霧後，再用 NAVY BLUE 在底座的四面中央部分薄薄塗擦上一層。乾燥後，再用刷毛較硬的毛筆（例如蠟紙轉印用的刷筆）沾水打濕後於其上來回刮擦，表現出烤漆已磨損掉色的殘破感。

After spraying the base with hairspray, a light coat of navy blue was airbrushed. A stiff brush soaked in water was used to activate the hairspray and chip off the navy blue, revealing a weathered finish.

12. 先上一層保護漆，再噴上一層美髮定型噴霧，接著再噴上一層 FLAT BROWN 的壓克力顏料。

Repeat the same process, using an acrylics matt brown as the top coat.

13. 和步驟11一樣，用刷毛較硬的筆刷沾濕後將咖啡色的部分來回刮擦掉。刮擦的重點爲四面的中央部分。生鏽的現象多半都是從角落或邊緣的部分開始產生，所以周邊的部分不太需要將顏料刮除。

The base after matt brown was scraped off using a stiff brush soaked in water. Rust tends to develop from the corners and edges, so the hairspray chipping is focused at the center of the base.

14. 再塗上一層保護漆。

Everything is protective after a coat of matt clear.

15. 使用毛筆沾取些許 AK Interactive 的 DARK RUST DEPOSIT，以點狀塗布於四面顏料刮擦處，靜置使其乾燥。乾燥後表面便會呈現粉狀的質地。

AK interactive's Dark rust deposit was stippled on in dots with a brush and let dry. This paint becomes powdery as it dries.

16. 用面紙將粉狀物太多的部分擦拭掉，使粉狀物留在凹陷處或四周角落即可。

Wipe off some of the previously applied Dark rust reposit. Try to refrain from wiping the corners and edges of the base.

17. 重複步驟15，先塗上 Medium Rust Deposit，再塗上 Light Rust Deposit 顏料，最後將作品名稱用水性色鉛筆寫上，接著再塗上消光保護漆。待乾燥後，將場景模型的部分組合於其上，便大功告成了。

Same technique was employed with Medium rust depost and Light rust depost. The title of the diorama was written in water color pencil and was top coated with matt clear.

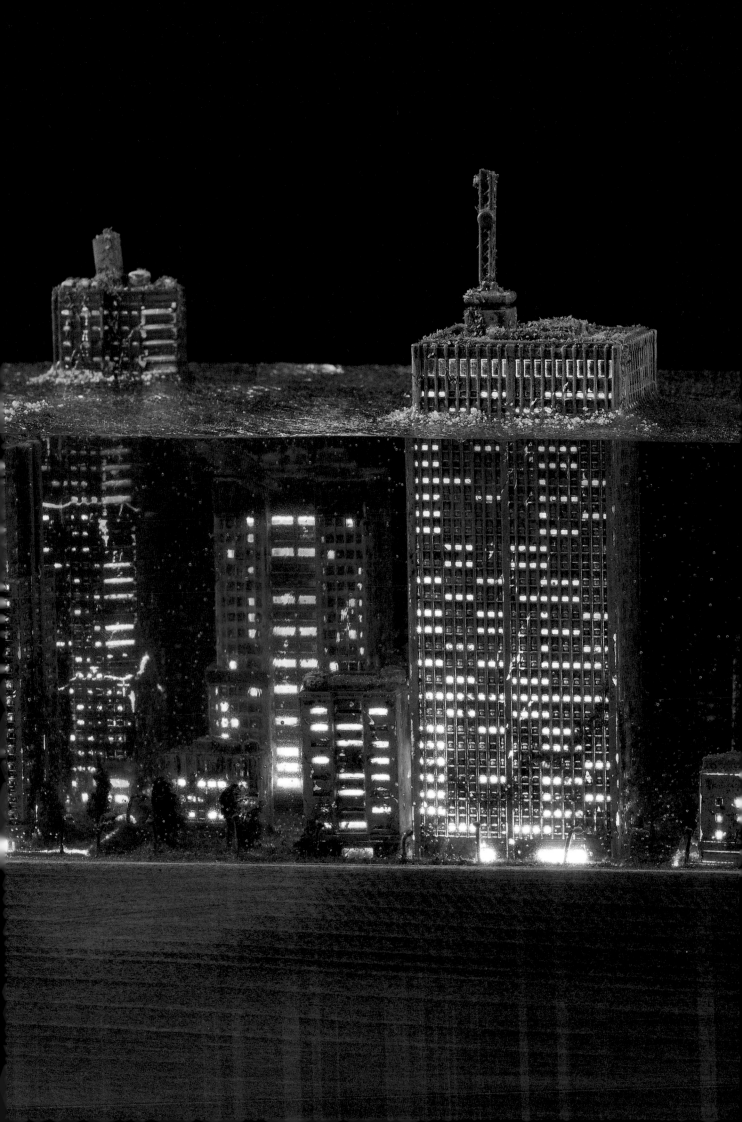

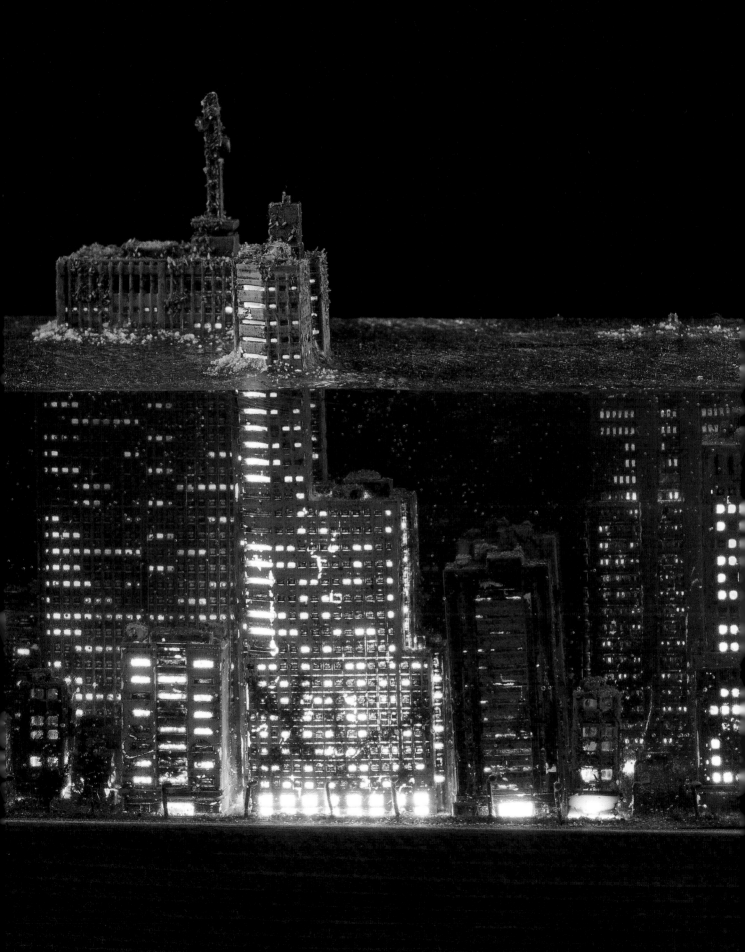

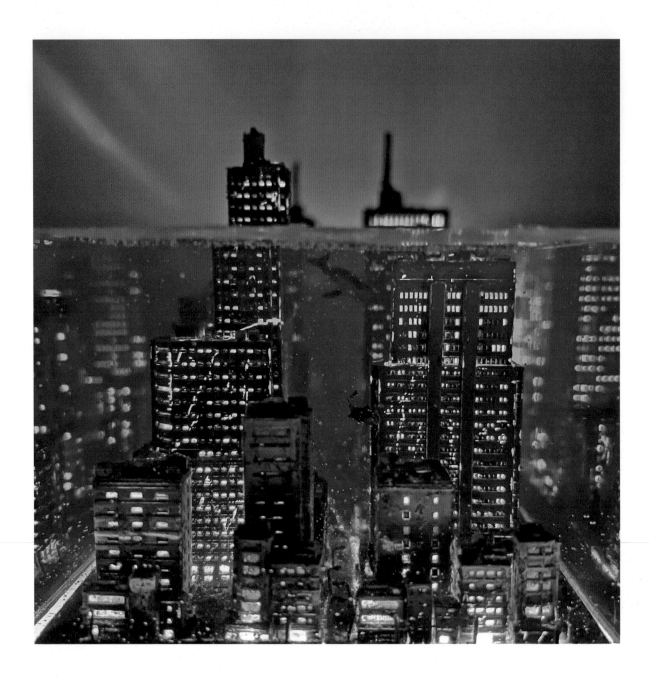

Submerged night view

 File_004

本作品的製作，是利用 3D 列印來製作遭水淹沒的大廈群。裝設燈飾時的導光體透明部件也是用 3D 列印製作出來的。在光線明亮的房間裡看著沒有打開燈飾的作品，可以感受到建築物沉沒在水中荒廢的狀態，也能從中窺見巨大的海洋生物身影。但若是在關燈全黑的房間裡，將燈飾的開關打開，氣氛立刻一變，水沒大廈群的窗戶燈光和街道的路燈明煌光亮，醞釀出滿滿的幻想氛圍。像這樣隨著環境明暗差異而有不同的欣賞方式，是一件具有兩種不同個性的水沒場景模型作品。

3D printer was used to create a series of submerged buildings.Transparent parts, which act as light conductors are also manufactured by 3D printers.If you look at the work in a well-lit room without the lighting on the diorama, you can see dilapidated buildings in the water as well as huge sea creatures.On the flip side, when lightings are turned on in a completely dark room, the window lights of submerged buildings and street lights sparkle, creating a very fantastic atmosphere.It is a submerged diorama with two characteristics, in which the way of enjoyment changes depending on the lighting of the room.

水没夜景

□ 2022 年製作
□ W:340 ㎜ × D:96 ㎜ ×H:150 ㎜

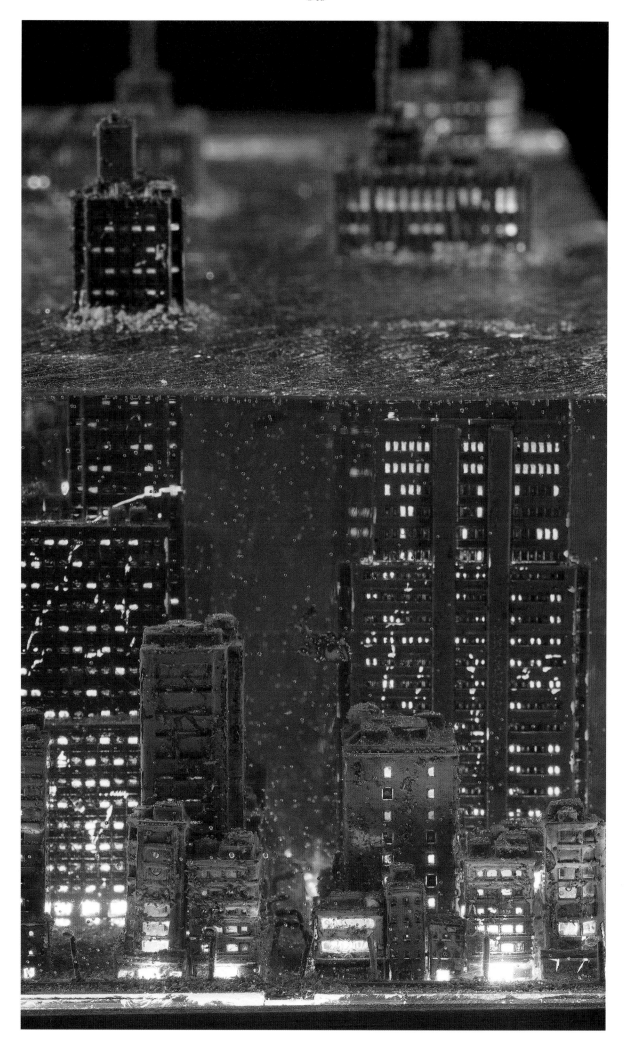

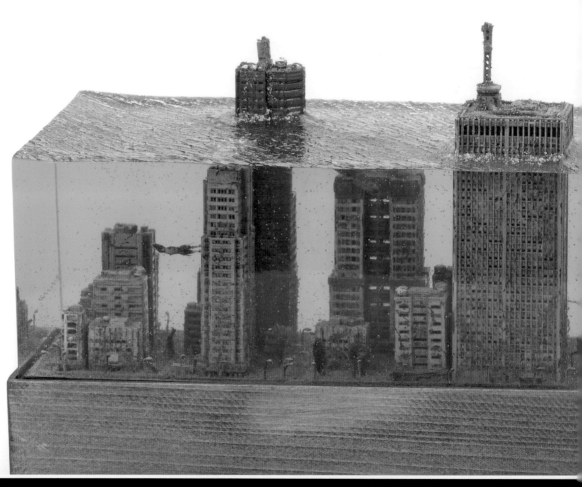

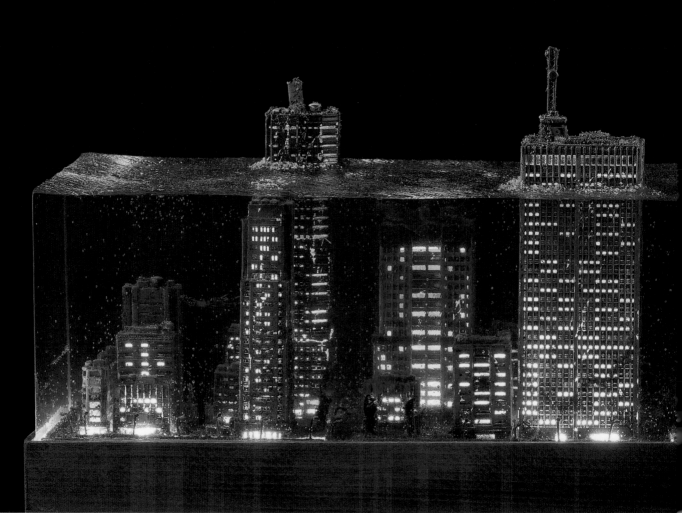

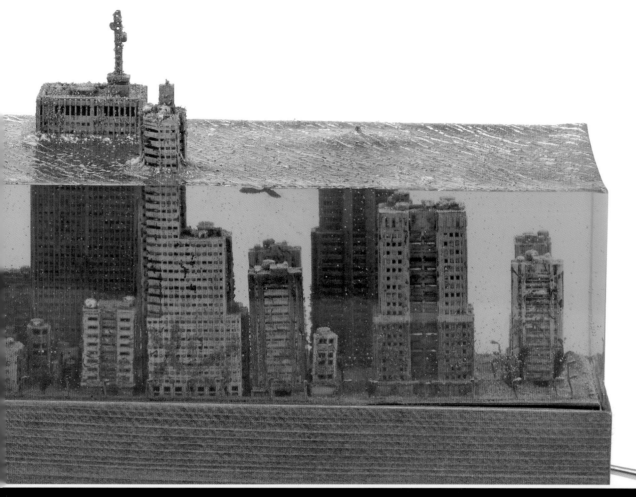

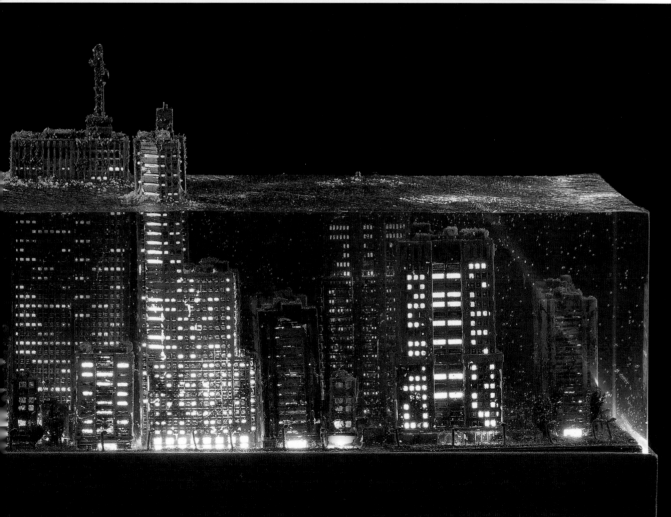

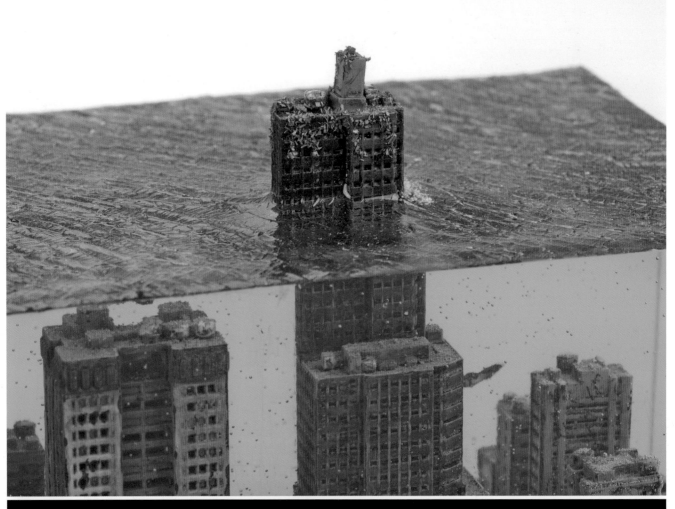

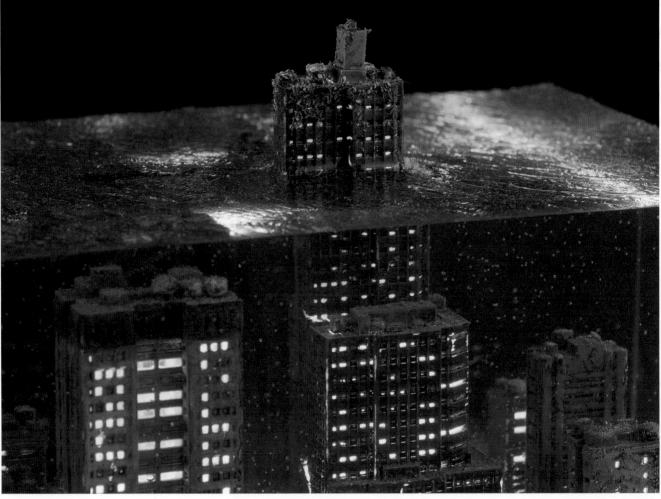

Submerged night view

01. 之前都是用手持電動磨刻機在 GEOCRAPER 上削出開口製作成窗戶，這次則是改用 3D 列印直接列印出已經開好窗洞的模型。經過多次嘗試及修正錯誤後，總算是成功了。

After testing it out several times, Masaki began printing out his own "damaged" buildings suited for his diorama. This opened up unlimited possibilities and enabled him to create a unique diorama.

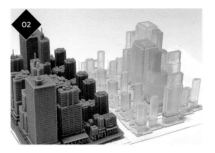

02. 若是直接使用內部空洞的大廈模型，裡面的空氣會在倒入樹脂液時跑出來。為了避免這種情況，也用 3D 列印製作出剛好能組合進大廈內部的透明部件。

The transparent "fillings" are printed out. These are designed to fit perfectly inside the buildings shown in step 1. Filling the inside of the buildings prevent air bubbles from forming during the resin pour.

03. 為了確認組合進去的尺寸是否恰到好處，先暫時組合上去做個測試，結果就拔不出來了。所以除了用來測試尺寸的那一組之外，其他的透明部件都是大廈塗裝完成後才組合進去的。

The fit of the transparent parts is very tight. As they can not be separated once combined, Masaki first finishes the painting steps of the buildings before inserting the transparent parts.

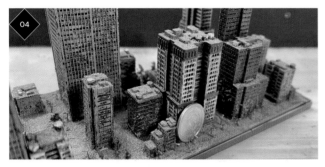

04. 和之前的作品一樣，將大廈一一上色，黏合在用來當成地面的壓克力板上，再利用土粉之類的素材或是仿真苔蘚來做地面的修飾。

The buildings and the ground were painted and detailed using previously explained methods. Seaweeds are replicated using the usual terrain material, such as moss powder and other model train diorama products.

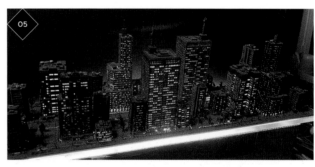

05. 將透明部件的數個窗戶薄塗上一層 CLEAR ORANGE 或類似的橘黃色，讓從窗戶透出的光線能有不同的色溫及色彩。在倒入樹脂液之前，要先打開燈飾開關做確認。

Some windows (or the inside transparent segments) are painted clear orange. This adds more variety to the building lights once illuminated with an LED.

06. 製作模板，水中的鯨魚就用釣香魚用的尼龍釣線懸吊在空中。

The molding frame is created using the usual method. Whales and other sea life are suspended using a thing fishing line.

07. 這次因為大廈類型的模型全都是用 3D 列印製作而成的樹脂部件，所以當在倒入樹脂液時，可以一次全部倒入。等待樹脂液硬化後，將模板剝除，並再次打開燈飾作檢查。

All the buildings are other objects were made of 3D printed resin with higher temperature tolerance than plastic, which allowed Masaki to pour resin in a single batch. After letting it cure, the mold was removed, and the LEDs were checked to ensure they were functioning correctly.

08. 海面上的波浪用無酸樹脂 GEL 凝膠劑製作，大廈的頂層也做好修飾塗裝。

Waves of the ocean were created using a gel medium. The exposed rooftops of the building received some more details as well.

09. 底座用木材製作，內部用鋁板來固定。在鋁板上貼上 LED 條燈，幫助條燈散熱。最後將底座和場景模型黏著固定，便大功告成了。

The base is made of wood, and an aluminum plate with LEDs installed is fixed inside. After assembling the base, the diorama, and the LED plate, the diorama is finished.

Cold sea

□ 2022 年製作
□ W:140 ㎜ ×D:86 ㎜ ×H:190 ㎜

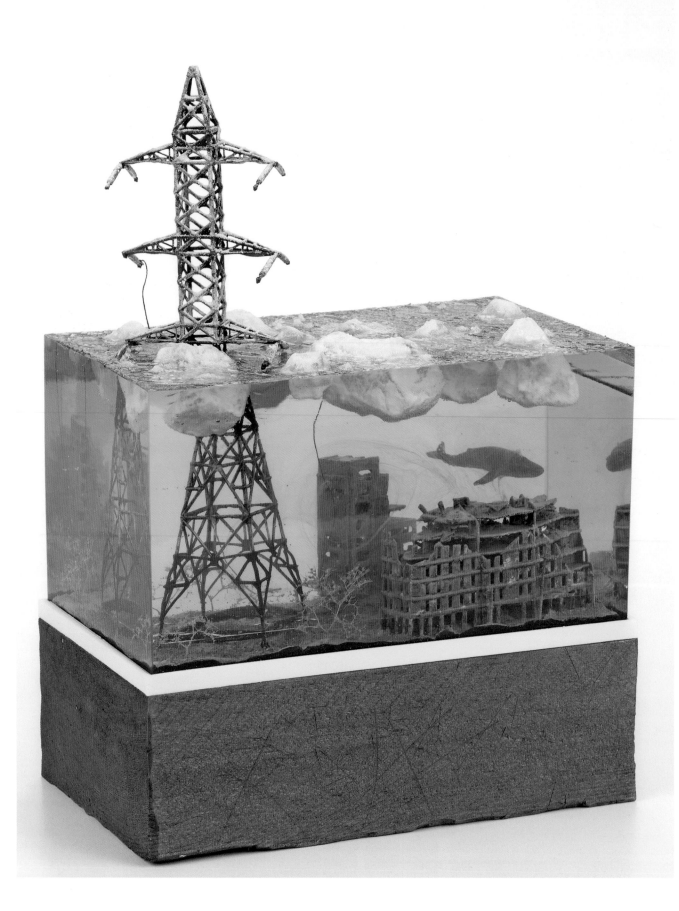

場景模型製作巨匠─吉岡和哉　談論MASAKI作品的魅力

利用「樹脂液」將時光凍結 作品的魅力封存於這一刻

MASAKI 先生傾盡心力製作的水沒場景模型有說不完的魅力，將此書拿在手上閱讀的讀者們想必都已經深知此事了。其中又以光線在水中反射時，表現出來的透明感及水波紋的美，最能使初次見到作品的人留下鮮明強烈的印象。

但是，光是這樣還不足以實際感受到 MASAKI 作品的深奧之處。沒錯，作品還帶有另一個魅力，那就是廢墟的存在。

曾經繁華的都市街景，隨著歲月的流逝、逐漸變化的模樣，總帶有令人惋惜感嘆的哀愁感。每一扇窗口都能感受到曾經有過的人煙氣息，朽壞的建物或荒廢的街道，每一處都帶有戲劇般的故事，那簡直像停佇在海面上，宛若墓標般的景象。

瑰麗的海洋和廢墟化的都市景象，雖然是完全相反的要素，但靛藍的水色和黯紅的鐵鏽色是互補的關係，在外觀條件上便已經十分引人注目。而充滿生命力的海洋和失去生氣的都市，兩者之間所形成強烈對比，更是任誰都能輕易與其中的抒情產生共鳴。

MASAKI 的作品就是靠這兩大特點牢牢地將人心抓住。利用「樹脂液」這種能將時光停住的水體，將時間封存在作品之中。這樣的世界觀，正是他的作品的最大魅力。對於 MASAKI 日後即將製作出來的新作品，也同樣令我們在內心充滿興奮與期待。

吉岡和哉

1968 年出生，居住於兵庫縣。日本知名 AFV 模型製作者之一。因為對年少時看過的特攝電影中的布景非常有興趣，而開始走上模型製作之路，此也成為製作場景模型時主體風格的基礎。目前擔任戰車模型專門誌《月刊 Armour Modelling》的顧問，藉由專門誌或是書籍來將戰車模型或場景製作的技巧不斷地展示於世間。同時也和塗裝顏料製造業者合作開發產品、在海外雜誌上刊載作品等，活動橫跨許多業界。同時也是 GSI Creos 公司出品的 Mr.Weathering Color 監修者。

I think readers who hold this book already know that Mr. MASAKI's life's work, submerged diorama, has myriad charms. In particular, the beauty of the transparent water expression reflected by the light will make a vivid impression on those who see the work for the first time. But that's not enough to make you realize the depth of MASAKI's work. Yes, there's another attraction to the work. That is the presence of ruins.

It is somewhat sad and pensive that the appearance of a once prosperous city has changed over the years. You can see a sense of human activity, and drama pervades the decaying buildings each window and dilapidated streets. It would look like a grave marker nestled at sea level.

The beautiful sea and the ruined city are contradictory elements, but the color of blue water and the color of red rust become complementary colors to each other and are physically eye-catching. Also, the contrast between the sea overflowing with life and the lifeless city is easy to convey and lyrical to anyone. MASAKI's works capture people's hearts with those two main points and never let go. It's a resin made water that stops time, and it locks time inside the work. That worldview is the greatest attraction of his work. And the anticipation of his work, which will continue to be created, has also captivated us.

Kazuya Yoshioka

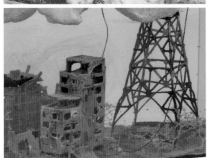

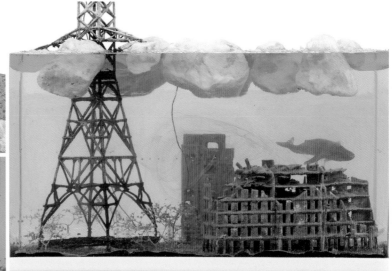

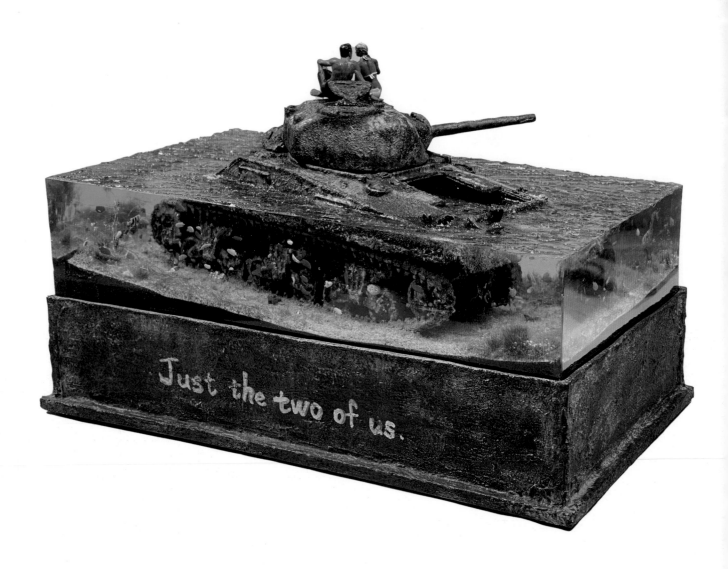

Just the two of us

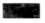 | File_005

刊載在 Armour Modelling 戰車模型專門誌 2021 年 9 月號的製作範例。作品的概念來自現實中沉沒於塞班島海域的眞實雪曼戰車。鏽蝕到連塑膠模型的原型都快要看不出來的雪曼戰車，那樣的姿態毋須言語，便能訴說其沉沒於水中的期間有多麼地漫長。人偶的呈現方式也十分具有戲劇性，給人留下深刻的印象。「眞實存在之物」也正代表了收集資料會很辛苦。在熱帶海洋中暢泳的色彩斑爛鮮艷魚群與鏽蝕損壞的戰車互成對比，是非常美麗動人的情景作品。

Just the two of us

□ 2021 年製作 (Armour Modelling 2021 年 9 月號刊載)
□ W:255 ㎜ × D:155 ㎜ × H:170 ㎜

Published on Armour modelling in September of 2021. The concept of this work is real-life shaman tank submerged in the see of Saipan.The shaman's appearance, rusty enough not to retain the original plastic model, speaks of the length of time the tank has been submerged in seawater. The way the figures are shown is dramatic and impressive.He had a hard time collecting materials because it exist for real.The contrast between the colorful fish swimming in tropical waters and the rusty, decaying tank is also a very beautiful.

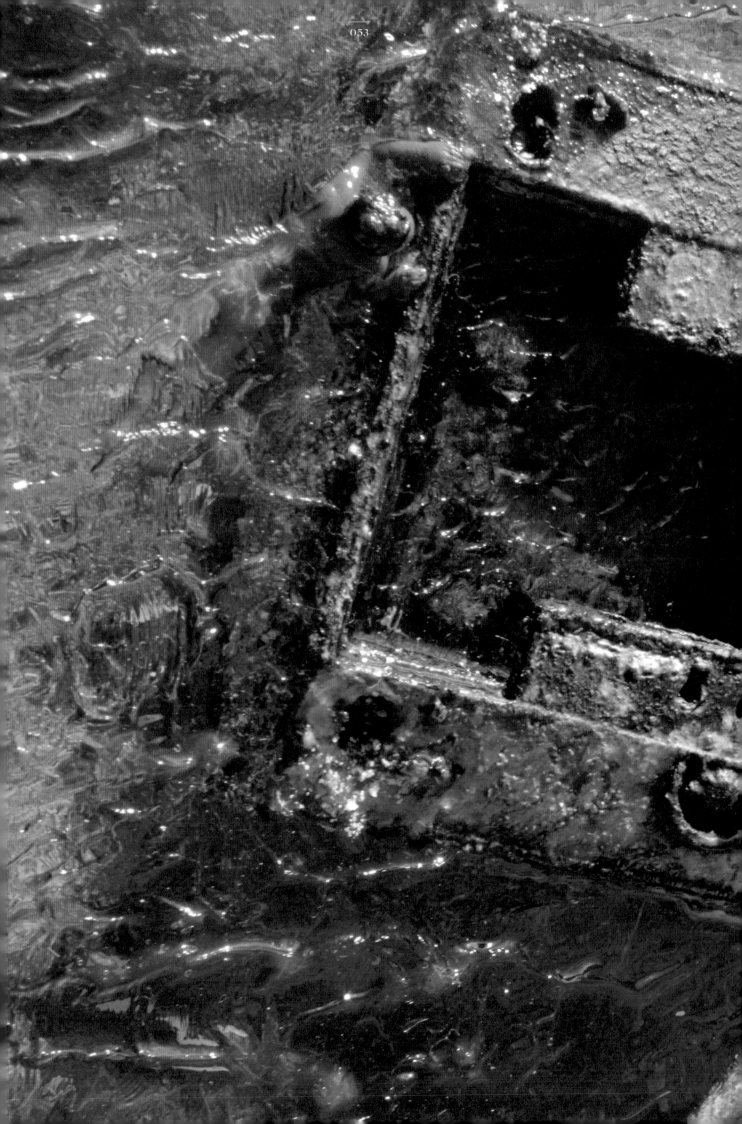

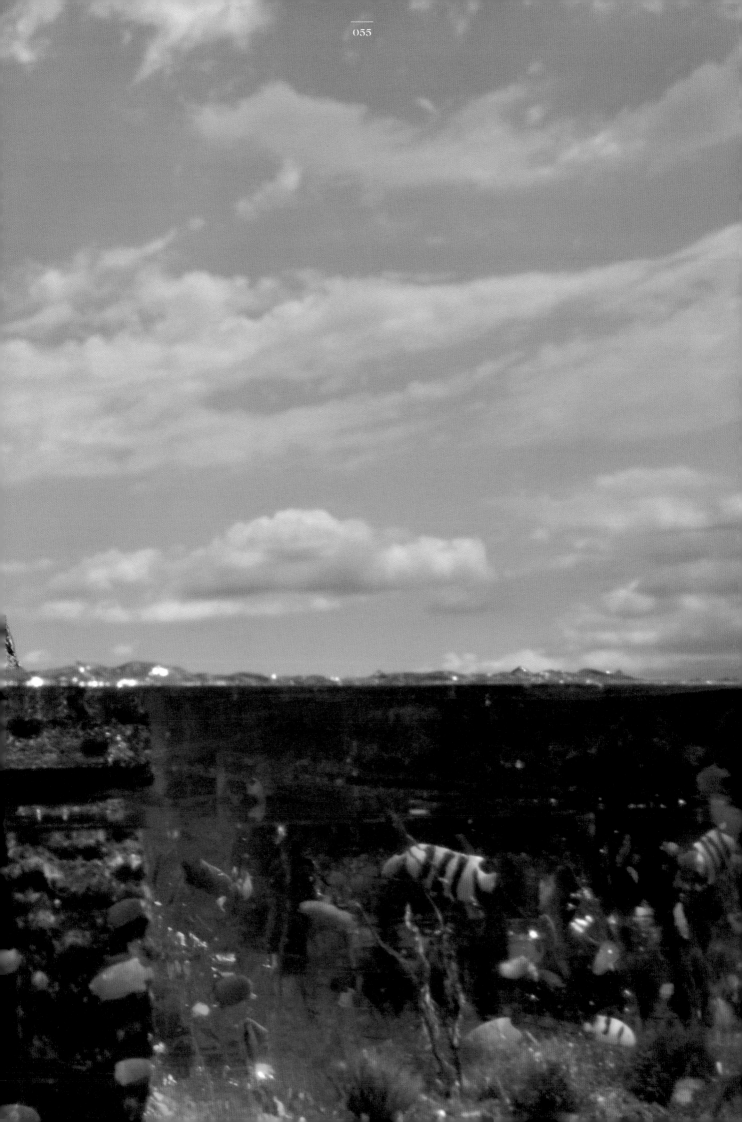

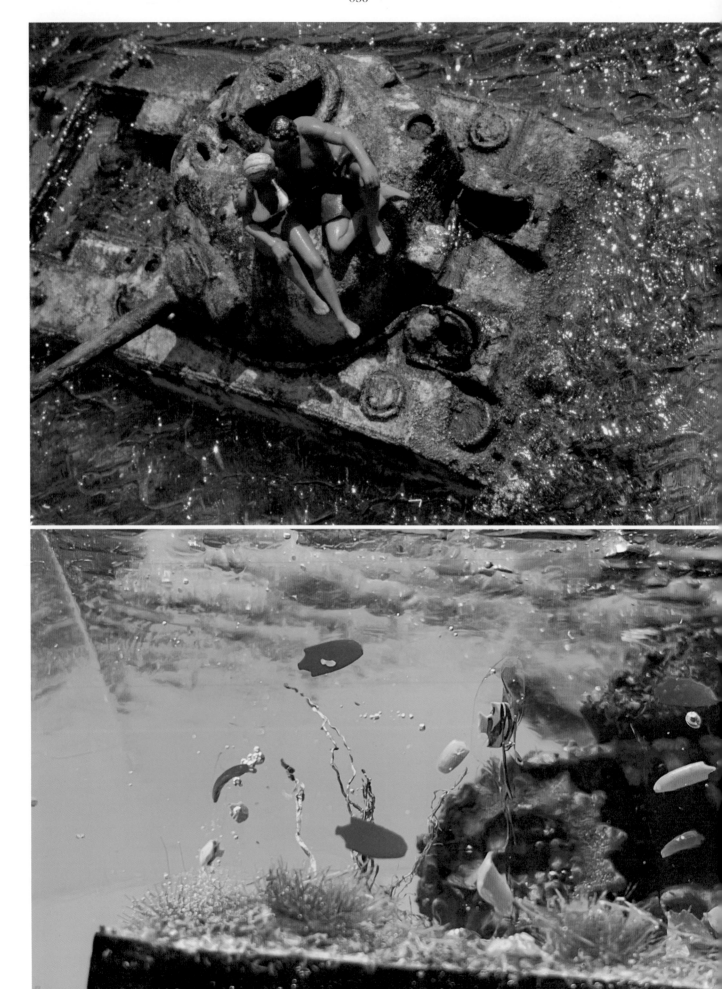

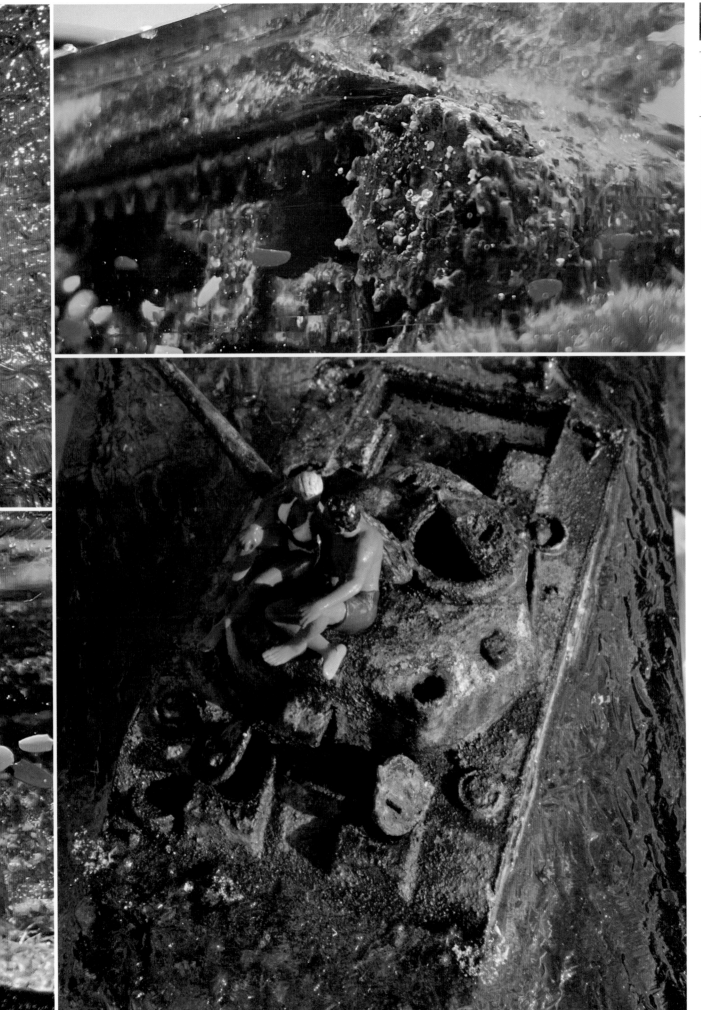

File_005

Just the two of us

01. 將兩片 5mm 厚的珍珠板貼合，爲了讓之後裝飾用的木粉黏土能好好黏附上去，需要預先將表面刮花。不過，黏土乾燥後會造成珍珠板稍微彎曲變形，若改用 2 至 3cm 厚的 Styrofoam 發泡塑料，就能防止彎曲變形。

Two 5mm thick styrene boards were glued together, and the surfaces were roughened to improve the adhesion of the wood clay. The boards warped a little, so Masaki suggested using thicker sheets (2 to 3cm).

02. 爲了防止龜裂，先將價格均一商店販賣的木粉黏土和白膠混合均勻後，再黏到珍珠板上。在黏土堆疊上去之前，先在珍珠板上塗上白膠，黏土會比較不容易脫落。

Wood clay mixed with wood glue (prevents cracking) is pasted on top of the styrene board. Don't forget to "wet" the board's surface with more wood glue beforehand.

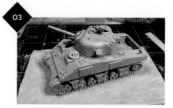

03. 在黏土乾燥之前，先決定好雪曼戰車大概要配置的位置，再將雪曼戰車往下壓，壓到履帶稍微陷進黏土中的程度，留下履帶的痕跡。

Position the tank before the wood clay dries. Once the position is finalized, press down the tank and its tracks to the wood clay.

04. 黏土乾燥後，將底部邊緣的部分切齊修平，貼上黑色的圖畫紙，再將「crushable stone」用白膠固定於表面。

Once the clay is dry, trim the edges of the base neatly. Use thick black paper to cover the vertical sides of the base. Glue some stones to the ground with wood glue.

05. 將在東急 Hands 買的「北美大陸之砂」灑上去，接著用加水稀釋後的 Superfix 萬能膠將其固定。

Finer stones and sands are sprinkled onto the ground and fixed in place using Superfix (type of matt medium) thinned with water.

06. 如果只是使用一種砂石，就太單調了。於是這裡就從上方灑下在沙灘撿回來砂子的砂子，用與步驟 5 相同的方式將其固定。

Different types of sand are sprinkled on again and glued down using the same method explained in step 5.

07. 將 Morin 的 Medium Grass 3 灑上去並固定，當作是海底的漂流物。

Morin's "Medium Grass 3" is scattered and fixed in place, replicating seaweeds underwater.

08. 將 JOEFIX 等廠牌的草葉素材，以自然且不單調的方式配置上去，相互之間要留下適當的間隔，再用白膠固定。

JOEFIX's and other brand's vegetation materials are used to add more variety to the diorama base. These are also great fillers to hide cracks that may have formed during the drying process of the clay.

09. 將乾燥的蘆筍葉切碎亦或是直接使用 Morin 的 Country Grass，將其灑在車輛下方或是離車輛稍微有段距離的地方。

Dried flowers, such as chopped asparagus and Morin's "Country Grass 2" are scattered under and slightly away from where the tank would be placed.

10. 地面佈置到一定程度後，將車輛設置上去，用施敏打硬的 SUPER X 系列（黏著劑）固定，在履帶和地面之間的縫隙灑上砂子或土粉，將縫隙填滿，再用黏著劑固定。

Once the groundwork is completed, glue the tank onto the base using Cemedine's Super X series adhesive. Sprinkle sand between the ground and the tracks of the tanks to eliminate any unnatural gaps.

11. 雪曼戰車的外觀質感是用 TAMIYA 補土混合用濾茶網篩過的拋棄式暖暖包內容物後，再塗在表面做出來的。固定好的雪曼戰車表面再追加灑上 Morin 的土粉，作爲海砂及堆積物。

The rusty texture of the tank was replicated using Tamiya putty mixed with the contents of a disposable pocket warmer. Sands and other debris were placed on the tanktop to simulate the passing of time.

12. 重現生長在車輛後端的藤壺，先使用從沙灘撿來真正的砂子以及 SUPER FIX 混合後塗抹在車身上，再用 Mr.Color 的 Light Aircraft Gray 做塗裝。

The barnacles at the rear end of the tanks are created using natural sand. These were mixed with Superfix and painted on the tank, and colored using Mr.Color Light aircraft gray.

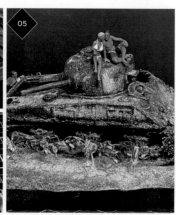

01. 要事先將魚固定住，才能做出有立體感的配置。首先在珍珠板上用雙面膠將塑膠袋以摺成波浪狀皺摺的方式固定住。

02. 在波浪狀的塑膠袋塗上黏度較高一點的 UV 膠樹脂液，再將已上色的魚類模型以立體的方式配置於其上。趁樹脂液還沒有流下來之前，趕快用 UV 燈的光使 UV 膠樹脂液硬化。

03. 樹脂液完全硬化後，將魚類模型從塑膠袋上剝除。

04. 人類就用 3D 模型繪畫來製作，直接拿 3D 列印的成品施加塗裝。

05. 砲塔上的男女最後才會固定，先暫時配置上去看看狀況。至於魚群則以三隻爲單位排列，再用 UV 膠樹脂液固定在地面。車輛後方的少年會抓著雪曼戰車不放，所以手的部分也要黏著固定住。

01. To replicate fishes, first fix a plastic bag to a styrene board using double-sided tape to create a wrinkly surface.

02. Apply UV resin over the plastic bags. Place painted fishes on top of the resin and cure under UV light.

03. After the resin has fully cured, peel off the fish from the plastic bags.

04. The human models were 3D printed and painted accordingly.

05. The two lovers on top of the turret are placed temporarily to see their fit. The boy and the fish are glued to the diorama at this stage.

01. 開始製作模板，使用2mm厚的PP(聚丙烯)板製作。要是用塑膠板之類的材質來製作的話，樹脂液會侵蝕進塑膠裡，造成無法剝離的事故，必須特別注意。為了防止樹脂液在收縮的時候，模板跟著一起變形，可以在中央的部分加裝一片內來強化結構的「橋板」。 02. 在組裝外箱時，保護膠帶在每一邊至少要貼3層，才能增加強度、防止漏液。 03. 底部的PP板要像圖中一樣，比製作的模型底部再多切出約2～3mm。PP板的大小若是和模型底部的大小太一致，可能會讓樹脂液無法完全流進底部側面，造成底部邊緣不均整。將底面和側面黏著固定，組合好整個模板。模板完成後，先將作品底部和模板的底部黏著固定。 04. 在混合樹脂液時，最好準備能量秤至0.1克單位的數位式電子秤。另外，考慮可能發生液體噴濺、灑出或漏液的情況，建議在操作的時候，最好能在托盤上進行或鋪上保護膜。 05. 事先混合好田宮模型琺瑯漆的CLEAR GREEN和CLEAR BLUE後，並在樹脂液的主劑中滴進三滴混合好的琺瑯塗料，仔細攪拌均勻。接下來，將樹脂液的硬化劑倒入並攪拌均勻。利用吹風機或熱風槍加熱樹脂液，可以讓氣泡更快消失散逸。氣泡消除到一定的程度後，也用吹風機將模板裡的溫度稍微上升一些，然後把樹脂液以細水長流的方式緩緩倒入模板中。注意一定要用細水長流的方式緩緩倒入，這樣才能將攪拌後樹脂液內的氣泡儘量打散消除。附著在模板邊緣或是沉在底部之模型周邊的氣泡，就使用熱風吹風機的熱風將之加熱來消除。就算這樣做卻還是消除不掉的氣泡，就用調色棒之類的工具將其撈掉。一開始只要倒到貼緊地面的淺淺高度就好，等待完全硬化，這樣比較不會從地面跑出氣泡了。 06. 硬化後，再將攪拌後的樹脂液繼續以步驟5的傾倒方式重複分數次倒入。若是一次倒入大量樹脂，會因硬化過程中產生的熱度而使模板中的塑膠部件因高溫而融化，最好能每次只倒入300克左右，等熱度減退、硬化後，再倒入下一次的量，這樣比較不容易失敗。在等待硬化的期間為了防止灰塵掉入，要在模板上加蓋。 07. 樹脂液倒到水面的高度後，為了使其完全硬化，必須放置24至48小時。 08. 完全硬化之後，模板便很容易剝除。若是在完全硬化之前就試圖剝除的話，樹脂液會像麥芽糖一樣被拉長而變形，要特別注意。 09. 水面邊緣隆起的部分，用美工刀切除。作業時要小心別讓美工刀滑掉而去誤傷到水面的側面部分。 10. 切除面的部分用耐水砂紙打磨平整。砂紙號數從120循序漸進到10000號，慢慢打磨至樹脂的透明感重現為止。

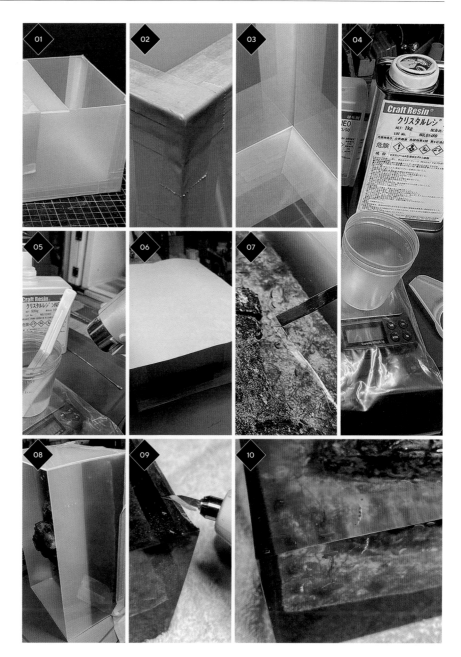

01. The molding frame is built using PP sheets with a thickness of 2mm. A "bridge" is located in the middle to prevent the mold from flexing inwards.
02. Masking tapes are taped on the edges to increase strength and minimize the possibility of resin leakage. When applying the masking tape, ensure it adheres tightly to the PP sheets, so there are no wrinkles or gaps.
03. The bottom of the mold is slightly larger compared to the base of the diorama. Once the molding frame is assembled, glue the diorama to the bottom of the mold.
04. A digital scale comes in handy when accurately measuring the resin mixture (the scale should be able to weigh in at 0.1g increments).
05. Add three drops of Tamiya acrylic clear green and blue to the primary resin solution and stir gently. Add the hardener to the mixture and heat the whole thing with a hair dryer or heat gun to make it easier for air bubbles to escape. Warm the inside of the molding frame slightly, and pour the resin into the mold in a thin steam. Scoop out any bubbles that may have formed during the pour using a coloring stick. The first resin pour should be just below the surface of the seabed.
06. Following the instructions explained in step 5, repeat the process several times until the ideal depth is achieved. While waiting for the resin to cure, cover the diorama with a lid to prevent dust and other debris from falling in.
07. Let it cure for at least 24 to 48 hours.
08. If the resin is cured fully, the molding frame should be easily removed.
09. Cut and trim the raised resin surface of the top resin surface with a sharp blade. Be careful not to scratch the verticle sides of the water.
10. Once the top edges are trimmed, polish using 120 to 10000-grit sanding paper.

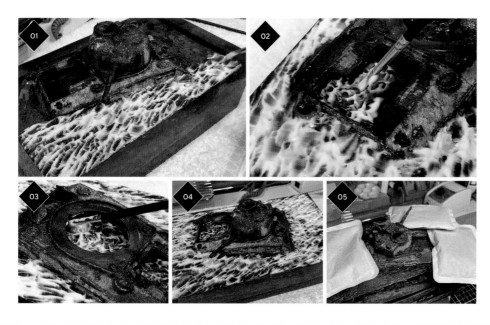

01. 使用無酸樹脂GEL凝膠劑來重現波浪的質感。這種素材在乾燥前是呈現白色膏狀的液體，但乾燥後就會變成透明，最適合用來表現水的形態。使用拋棄式的平筆，一邊想像著波浪的形狀，一邊塗上無酸樹脂GEL凝膠劑並塑形。 02. 引擎室內的波浪比較不容易受外側的海浪影響，浪花的表現要做得比較小一點。 03. 砲塔內部模樣，可能會從艙門的縫隙間被看到，所以也需要做出波浪的形狀。 04. 檢視全體波浪的平衡時，不斷反覆微調波浪的形狀，直到滿意為止，接下來就是等待其完全乾燥。 05. 有時即使過了一定程度的時間，表面已經反覆乾燥凝固了，但內部卻還是呈現白濁的狀態。碰到這種狀況時，就用拋棄式暖暖包緊緊貼在上面熱敷，再用瓦楞紙箱整個罩住，就有機會讓白濁的狀況消失。

01. Waves are replicated using a gel medium. Gel medium is a white paste-like liquid that becomes transparent once dry. This medium is applied with a disposable flat brush.
02. The waves inside the tank's hull should be smaller than the outer waves. Keep this in mind when working in these confined sections.
03. Although it is most likely to get hidden once the turret is placed, the crew section of the tank's hull also received the "wave treatment," just in case.
04. Fine tune the waves until you are satisfied with the overall balance and feel of the ocean. Let it dry over night or until the waves become transparent.
05. If some parts of the wave remain milky white even after given a lengthy drying time. Consider warming up with disposable body warmers.

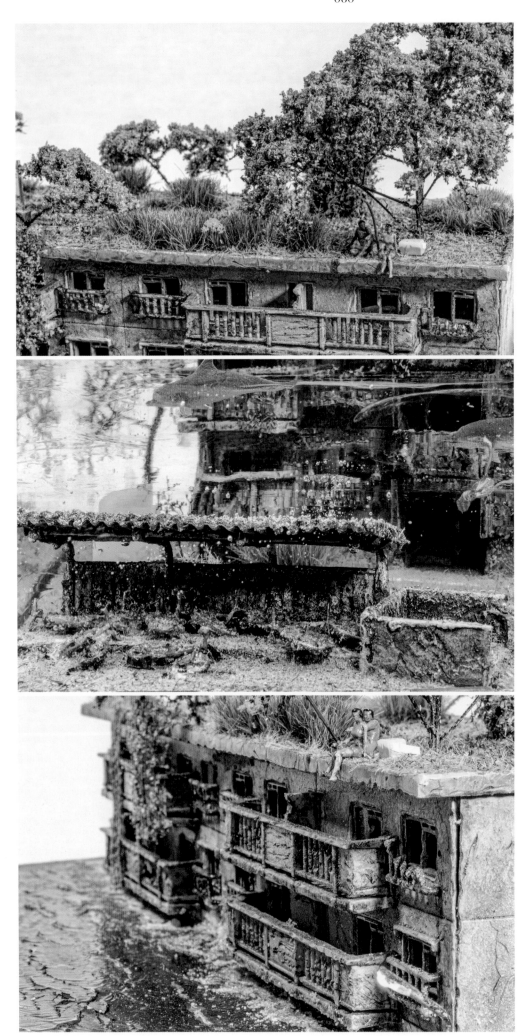

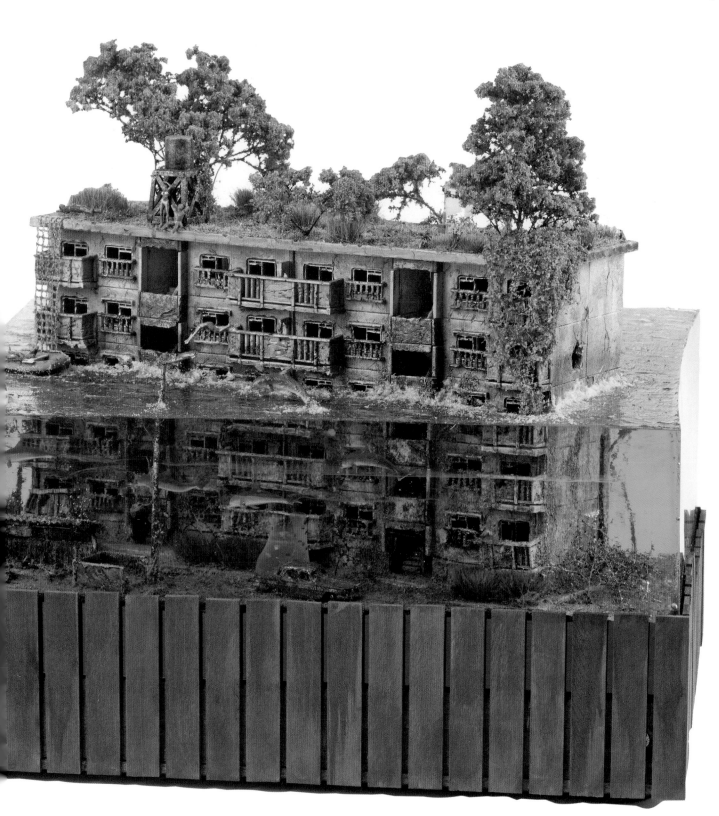

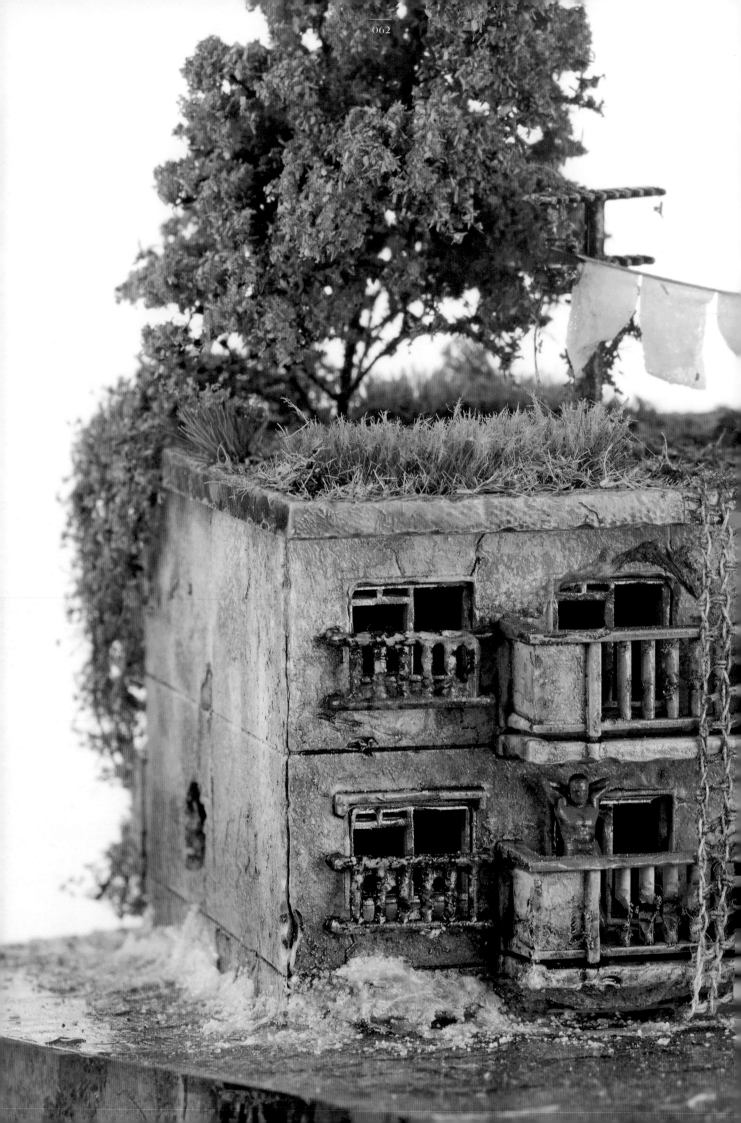

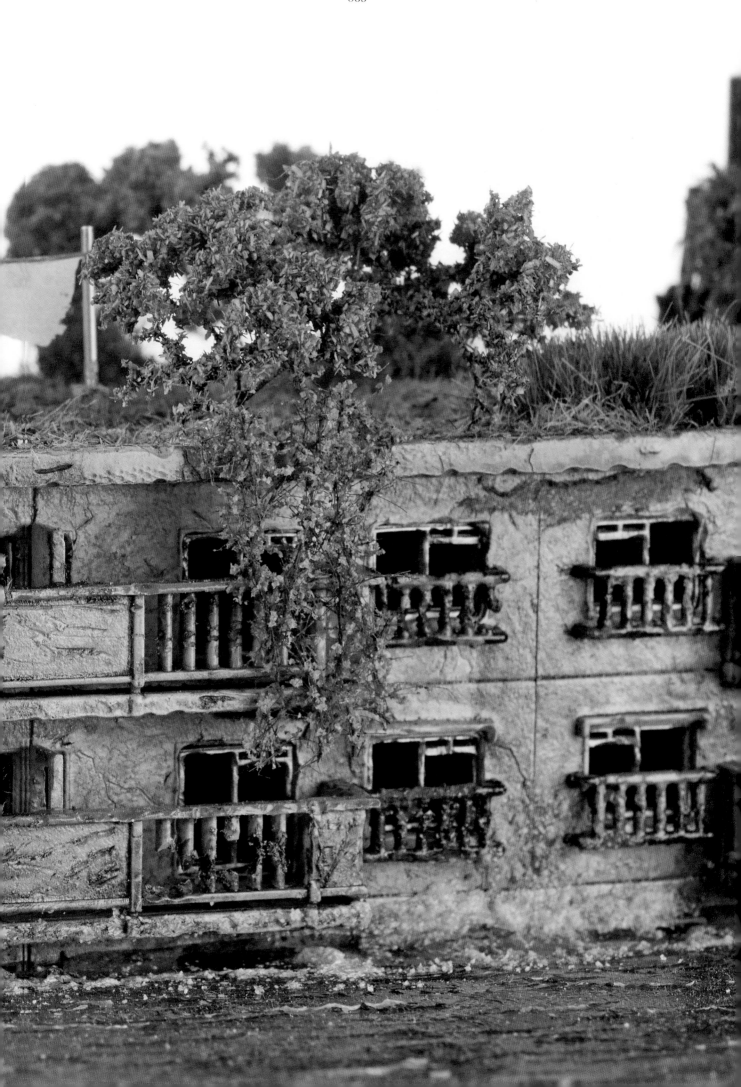

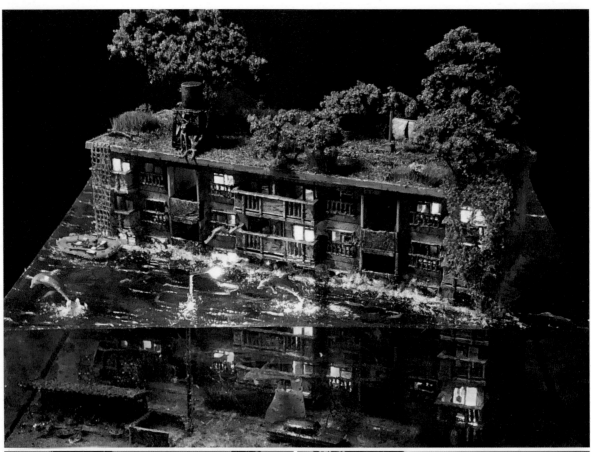

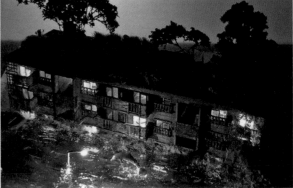

Summer day

 | File_006

本作品的表現主旨爲一群年輕人來到水沒後的荒廢住宅社區，開心遊玩的歡樂模樣。作品的規格在 MASAKI 的作品當中是較大的 1/150，製作時更是著重於要讓觀看者能夠清楚感受到人物設定上的各種細緻氛圍。住宅社區每個房間的內部，因爲是現成的商品，所以就利用 3D 列印來製作後組裝進內部，將房間格局及被棄置的家具都呈現出來。每個房間的窗框也是用 3D 列印出來自己製作的。人們在屋頂或陽台上開心遊玩的身影，在住宅社區內游泳的鯨魚母子，海豚飛躍於水面上的姿態，像這樣尋找作品中的不同亮點，也是欣賞本作時的樂趣之一。

夏日

□ 2020 年製作
□ W:245 mm × D:190 mm × H:220 mm

Young people enjoy visiting an abandoned housing complex submerged in water. Because the scale is 1/150, which is a bit large for a MASAKI work, the diorama is made to feel the atmosphere of the people in detail. The interior layout of the rooms and the remaining furniture are 3D printed and put together with kit's floor. The window frames in each room are also hand-built using a 3D printer. It is fun to look for attractions such as people enjoying themselves on the rooftop and on the veranda, a father and son of whales swimming behind the housing complex, or dolphins bouncing on the water surface.

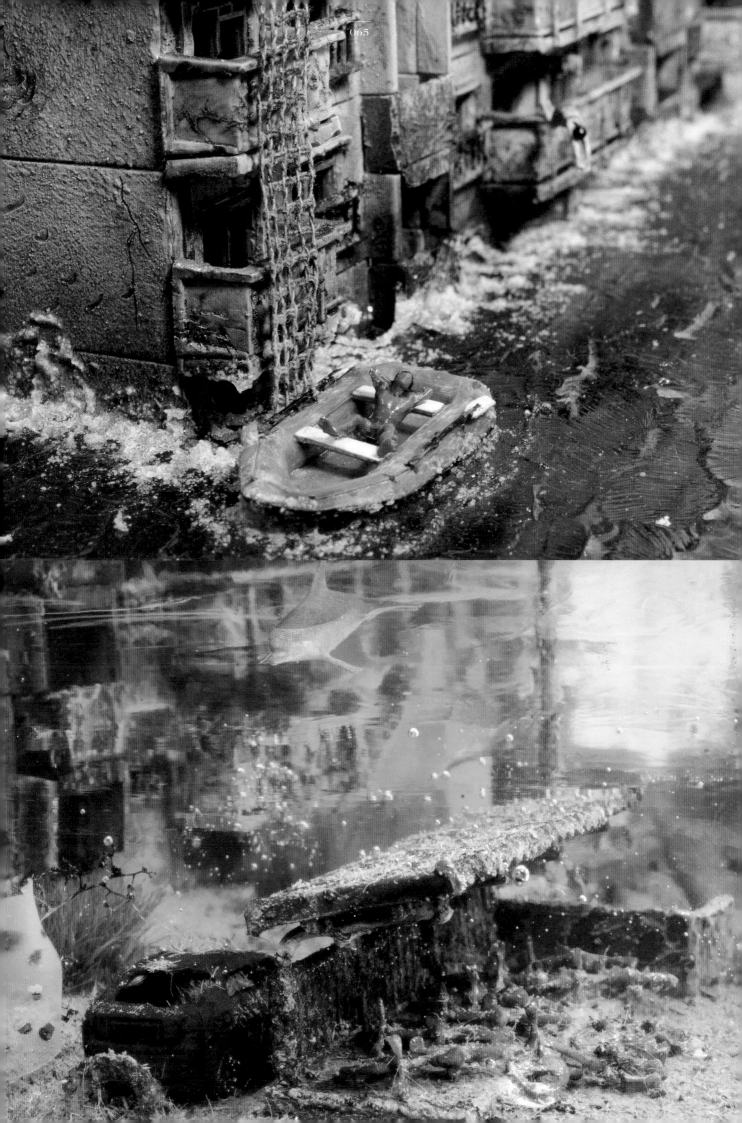

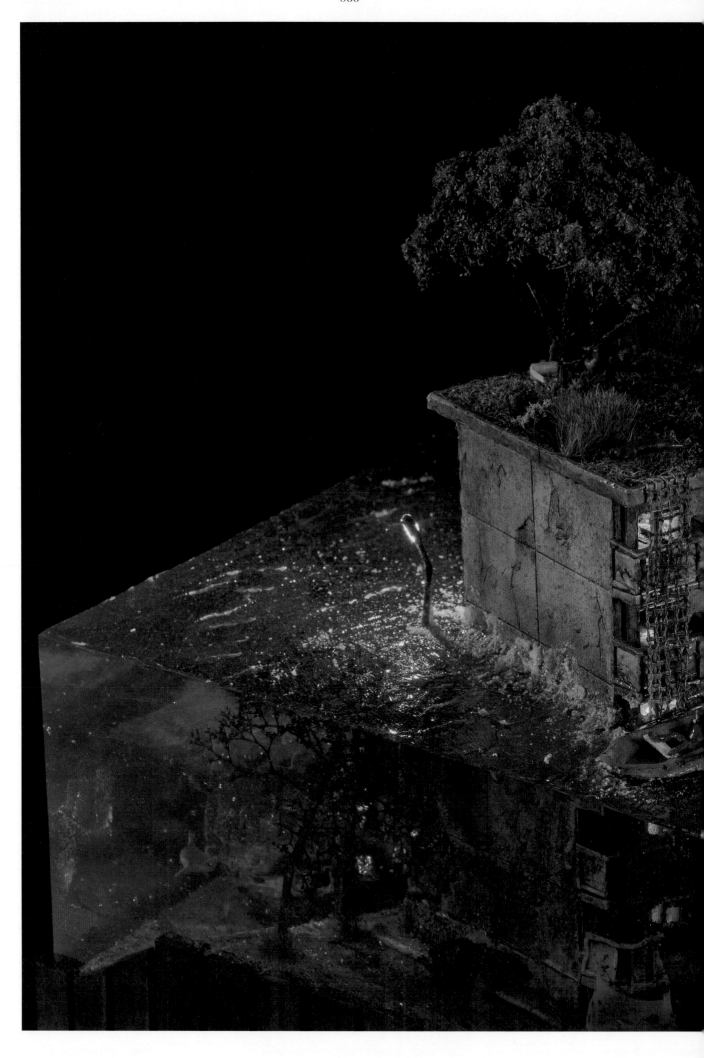

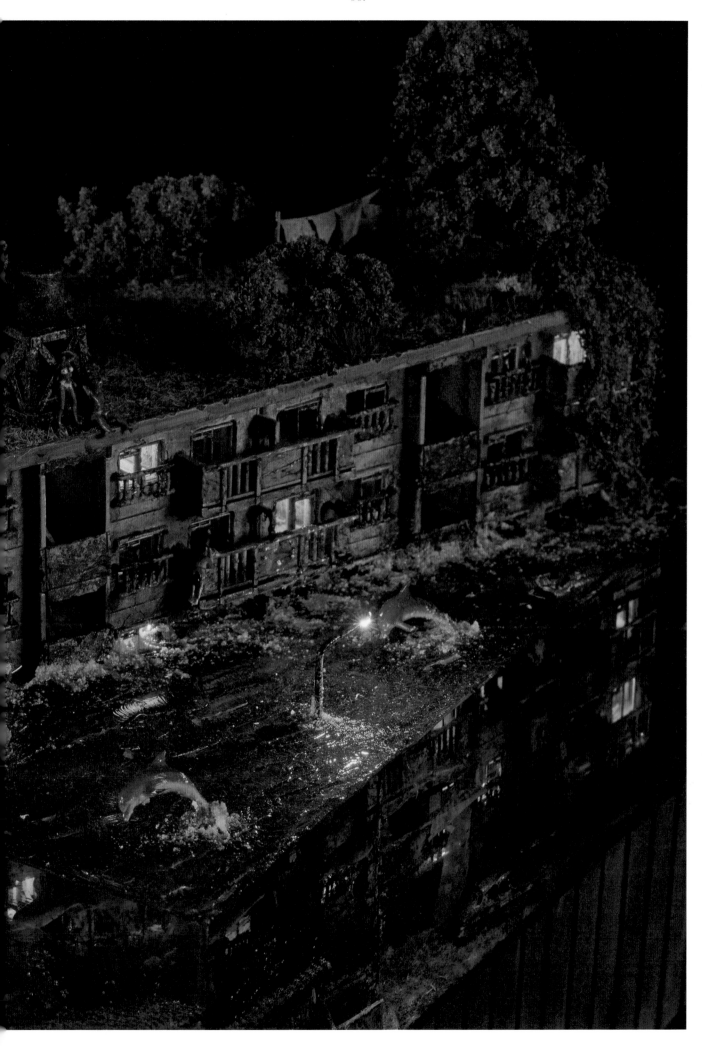

File_006

Summer day

01. 使用的是アオシマ公司製作的公寓住宅塑膠模型，但因爲內部幾乎沒有任何隔間或裝潢家具，就用 3D 建模來製作，再將 3D 列印出來的成品組裝進去。

The apartment complex is from Aoshima's injection plastic kit. The interior of the building was scratch-built using a 3D printer.

02. 現成套件的公寓窗框，原本是用透明部件加上貼紙來呈現出不同顏色的效果，所以這邊也用 3D 列印來重新製作。從內側組裝上去。

The window frames were also 3D printed and mounted inside the apartment rooms.

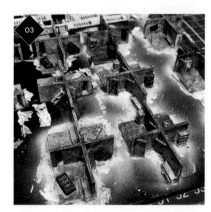

03. 在內裝的部分隨機塗上液態補土後，開始進行塗裝。

Liquid putty was randomly applied to the interior. Each room was detailed painted using a brush.

04. 接著將會沉在水中的部分用青苔色的塗料做漬洗，水面上的房間內裝則用 Mr. Weathering Color 的灰色系或黑色系的塗料來做漬洗。

You can notice the difference in painting style between the rooms above and below sea level. The rooms on the lower floor received a gray and black wash (Mr.Weathering Color).

05. 將內裝組合，把燈飾打開，並確認整體觀感。相較於內部什麼都沒有的狀態，加上內部裝飾後，果然變得好看許多。

Test assembly with LED lights. The apartment looks much more realistic with added scratch-built details.

06. 外壁的部分用手持電動磨刻機來追加磨損和傷痕，在不同部位塗上基本色後，再塗上舊化塗料。

The outer walls of the apartment were damaged by a drill bit. After painting the base colors, the entire building was weathered quite extensively.

07. 地面用珍珠板或是 Styrofoam 發泡塑料來製作。後方的公園用 3D 列印製作。

The base for the groundwork was mase using a styrene board and styrofoam. The small park behind the apartment was 3D printed.

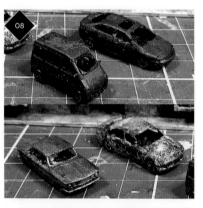

08. 車輛使用的是鐵道模型中 N 規用的車子模型。切削出車窗並追加傷痕後，再施以鏽化的塗裝。

Cars for model train dioramas were modified by opening up their windows, adding damages, and weathering to give them a beaten-up rusty look.

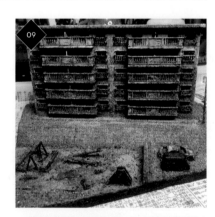

09. 將住宅社區的其他硬體設施、車、腳踏車停放區等小型部件固定好，地面施加塗裝，接著塗上消光無酸樹脂凝膠劑後，灑上草粉。

The apartment, cars, and other small objects were glued to the ground. The ground was then painted and received the usual powder treatment to replicate seaweed and seabed sediments.

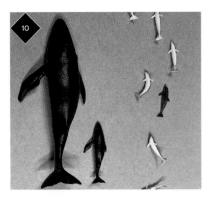

10. 水中的生物是以 3D 列印製作並施加塗裝。製作時我忘了塗上保護漆,在倒入樹脂液時,鯨魚腹部的白色塗料便溶化掉色了。

Underwater creatures were 3D printed and painted. Make sure you coat everything with clear lacquer. Masaki forgot to apply a protective coat to the whale, resulting in its white belly melting away......

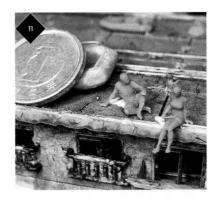

11. 在其他作業的同時,還一併預先製作了登場人物的 3D 建模,設計出各種各樣的人物姿勢後,以 3D 列印做出來備用。

Human models were also 3D printed in various poses.

12. 製作模板,倒入樹脂液。製作時還是殘暑正盛的九月上旬,硬化時產生的熱度非同小可。

The molding frame was made from PP sheets, and resin was poured in carefully. The weather was still hot and humid at the time of this pour, so the reaction heat was quite extreme.

13. 因為硬化時的高溫影響,鯨魚的白色塗料溶出,畫在小魚身上的透明塗膜也因此白化,雖然有這些意外事件發生,也不能輕易放棄,繼續朝完工邁進。

The unusually high temperature caused some damage to the diorama. Notably, the white paint of the whale's belly dissolving, and the transparent blisters with small fish painted on them turning white.

14. 用無酸化樹脂 GEL 凝膠劑製作水面,追加在水面上跳躍的海豚。

Waves were formed with a gel medium, and jumping dolphins were added.

15. 來到此處的人所乘坐的橡膠船,也讓其漂浮在公寓建物的附近。

A small rubber boat was placed in the water to indicate that the settlers likely arrived using this orange boat.

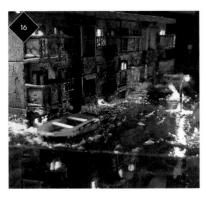

16. 這時再次打開燈飾,確認全體狀態。

Shine the light through the diorama to check for the overall atmosphere and correct any errors if spotted.

17. 最後在住宅社區的屋頂上追加雜草和樹木,展現出長時間被棄置未整理的模樣。

Finally, add grass and trees to the rooftop of the apartment complex to give the feeling that it has been abandoned and surrounded by nature for a long time.

18. 將人物個別塗裝上色後,配置於適當之處。最後將底座製作並組合,便大功告成了。

The human figures are placed on the rooftop after painting. Add the diorama to the separately built base, and the work is finished!

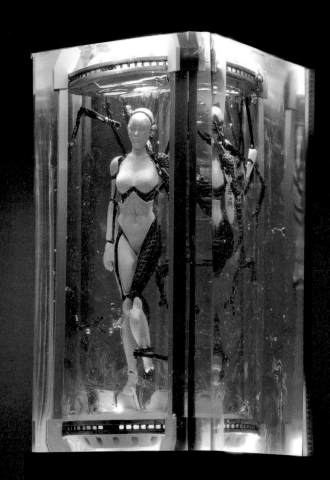

Relics of the past

 File_007

過去的遺物

☐ 2019 年製作
☐ W:210 ㎜ × D:210 ㎜ ×H:340 ㎜

爲了參加 HOW HOUSE 主辦的*GO!俺のロボ展〔レトロフューチャー編〕而製作的作品。這是我自己首次完全自製並設計的機械人形，3D 建模使用的是 3DCG 軟體的 Maya，再以 3D 列印製作而成。在復古的氛圍裡又加上一些現代的味道，高度進化的人類文明滅亡後，沉睡在被遺忘的地下設施中的人型機械人便完成了。在倒入樹脂液時偶然出現了塗料溶出的狀況，這個意外事件，反倒令作品更顯生動。

The diorama built for an exhibition hosted be HOW HOUSE. His first original robot design, which was modeled in the 3DCG software Maya and output using a 3D printer. It's retro with a modern touch, and finished as an android resting in a forgotten underground facility where advanced human civilization has perished.The unexpected flow caused by the paint that accidentally melted when resin was poured into the work creates movement in the work.

* 譯:GO!我的機械展〔復古未來篇〕

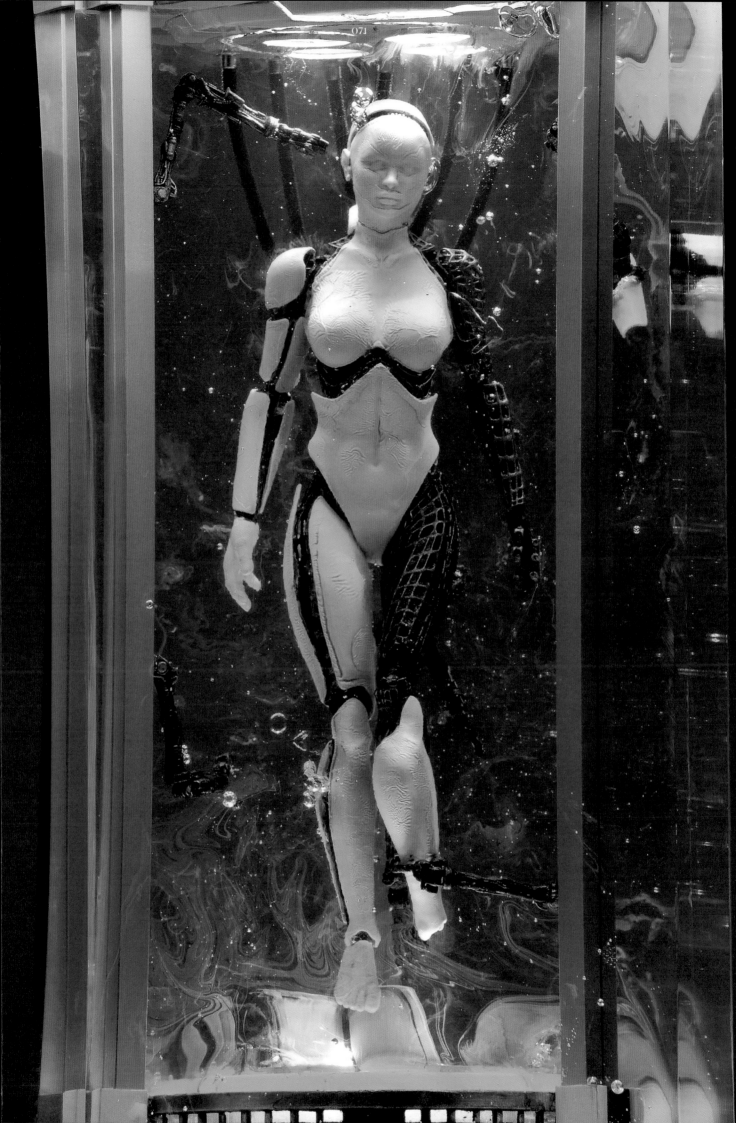

Relics of the past

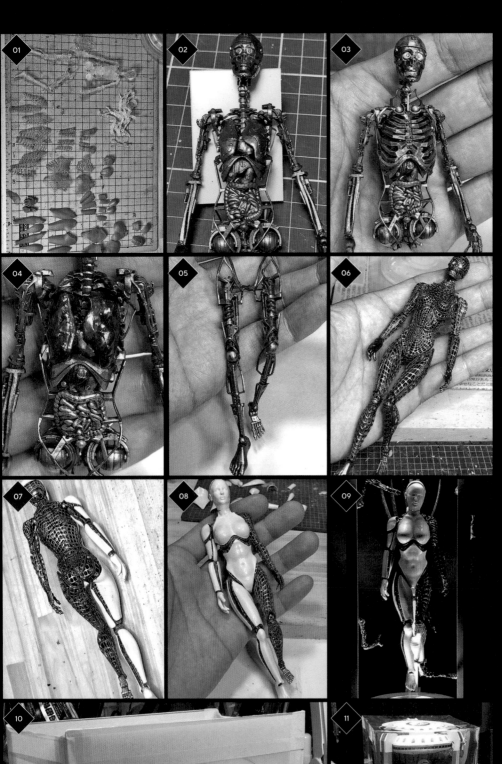

01. 爲了參加 HOW HOUSE 主辦的*「GO！
俺のロボ展」聯合展而製作的作品，因爲是
首次完全自製並設計的人型機械人，所以全
部零件先使用 3D 建模後，再分別用 3D 列
印製作。
02. 先在骨骼的模型上覆蓋網狀框架，接著
再將裝甲覆蓋上去，以這樣的形式來進行製
作。首先將所有的部件都塗裝黑色，再用
Mr. Color 的 SUPER IRON 塗裝成銀色。
03. 雖然完工後這些部分幾乎都看不見，但
還是要將每個部分分別塗裝上不同的顏色。
04. 肋骨下還有內臟的部件，就先塗裝成金
屬色。
05. 下半身的骨骼，因爲還會連接上減震器
的零件，於是裝彈簧的部分塗裝成紅色，做
出重點色。心裡都是抱著「之後可能會從隙
縫之間看到裡面」這樣的想法來製作的。
06. 在骨骼罩上網狀的框架。
07. 將白色的裝甲逐一黏著固定上去。這次
想展現的是人型機械人在製作途中就被放棄
不管的模樣，所以左半身會是還未將裝甲組
裝上去的狀態。
08. 主要的機械人模型完成。
09. 因爲想做出人型機械人在貯存室中組裝
的樣子，於是便增加製作垂吊而下的配線等
物品，並在機械人的上方與下方加上會發光
的底座機關。
10. 將其以橫放的方式倒入樹脂液。好處就
是能在一定程度上控制氣泡的位置，而且從
正面看的時候，樹脂液分次倒入時的痕跡也
會比較不明顯。
11. 從模板取下後，稍作細部的打磨，在上
下裝設帶有 LED 燈的配線及開關等裝置，便
大功告成了。

01.This particular build was built for a special
"Go! MyRobot Exhibition" exhibition held in
Japan. Masaki designed, modeled, and 3D
printed the robot.
02.The robot consists of inner parts, a mesh-
like outer framing, and armor platings. First, all
parts were painted in black, followed by Mr.Color
Super Iron.
03.Each section of the inner part was painted
separately. Most of these details will be hidden
once everything is assembled.
04.More of the inner details are painted. These
resemble vital human organs.
05.The lower inner segment of the robot. Notice
the large dampers/suspension on the left and
right "thighs."
06.Mesh-like outer framing covers up the core of
the robot.
07.The white casing replicates an armor plating.
The left half of the robot is not yet armored,
giving it a semi-completed look.
08.The assembly of the main robot is finished.
09.The robot is connected to the tank via various
cables to give the impression of it being built in
an aquarium-like environment.
10.The resin is poured in while the robot and the
tank are laid down sideways. This way, air bubbles
are much easier to deal with, and each resin
layer's seam is less noticeable when viewed from
the front.
11.The resin block is separated from the molding
frame and polished, and LEDs are placed on the
tank's top and bottom.

* 譯:GO!我的機械展

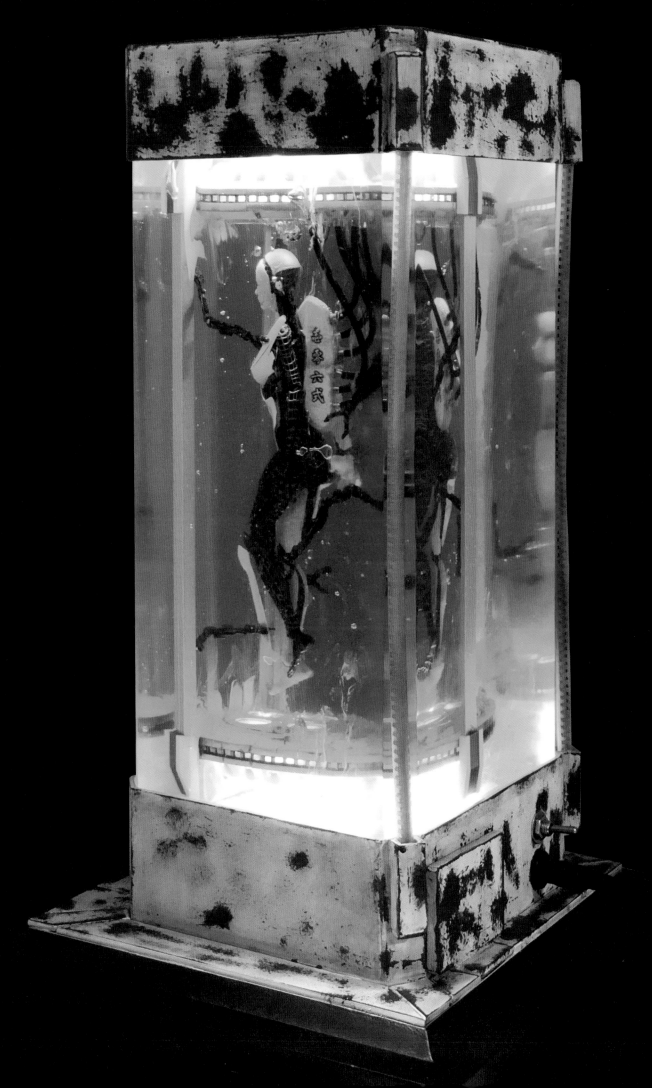

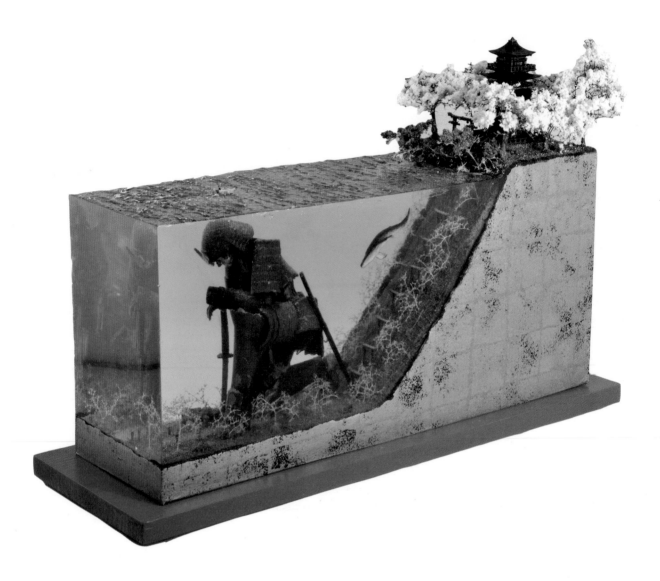

All things must pass

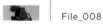 File_008

諸行無常（紅）（白）

☐ 2021 年製作
☐ W:300 mm × D:100 mm × H:250 mm

這也是爲了參加 HOW HOUSE 主辦的*GO！俺のロボ展〔ジパング編〕而製作的作品。是將前項作品『過去的遺物』中製作的人型機械人，穿上甲冑，變身成爲巨大機器人，呈現出在水底力竭而單膝跪下，等待主人歸來的氛圍。因爲主題是「日本和風」，於是在山坡上佈置了五重塔和櫻花。場景模型的側面使用了宛若金色屏風的和紙，底座則用朱紅色的木板來製作，和風的感覺更加提升，使作品在視覺上更加豐富多彩。人型機械人做了紅白兩個種類，成爲兩件一組的作品。

Also built for another exhibition hosted by HOW HOUSE. The android created in the previous work, "a relic of the past," is dressed in armor and transformed into a giant robot, which is then finished in an atmosphere of exhaustion at the bottom of the water, getting down on one knee and waiting for its master to return. A five-storied pagoda and cherry blossoms are placed on the slope to match the theme of the exhibition, "Zipangu" The sides of the diorama are made of Japanese paper with a gold folding screen, and the base is made of vermilion plates to enhance the Japanese atmosphere and enliven the work.The android is produced in two kinds, red and white, and the two make a set.

* 譯：GO！我的機械展〔日本和風篇〕

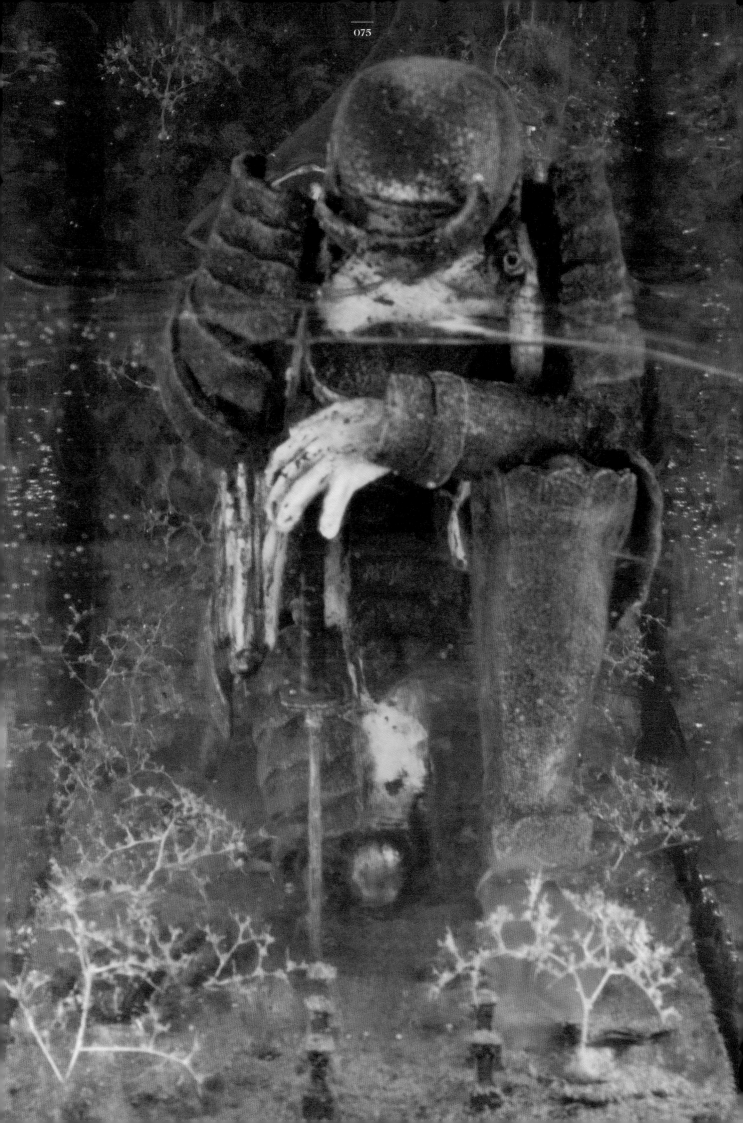

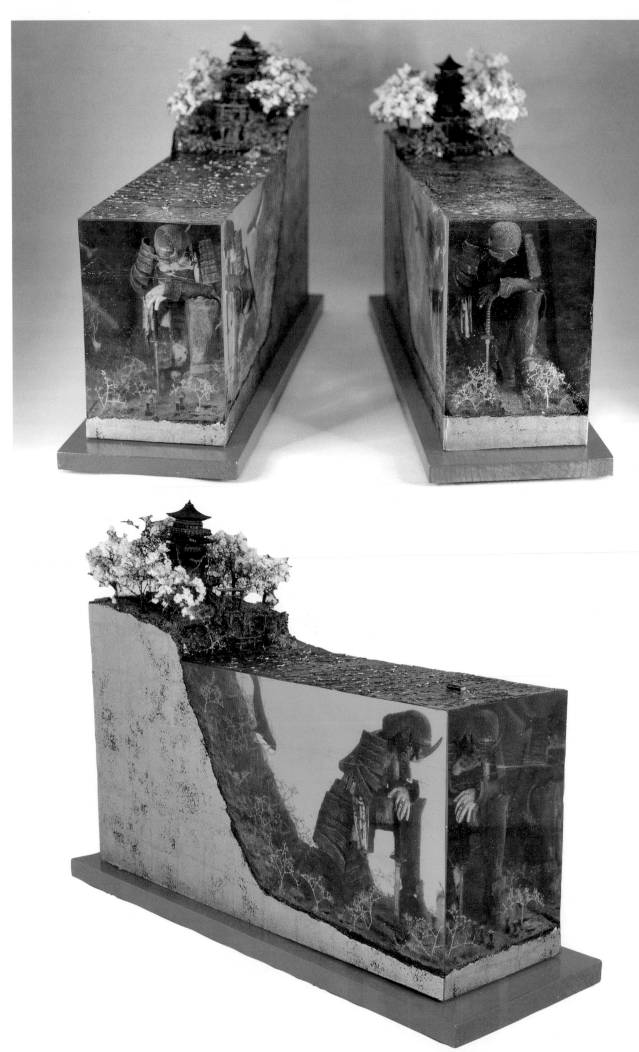

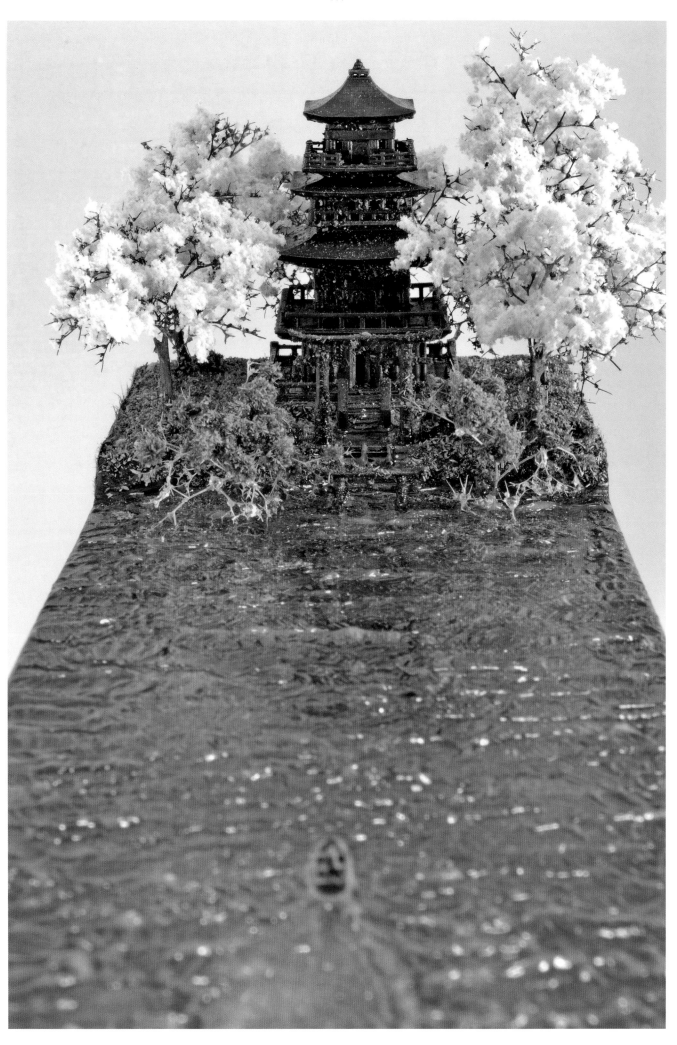

File_008

All things must pass

01. 爲了參加 HOW HOUSE 主辦的*GO！俺のロボ展〔ジバング編〕的聯合展出而製作的作品。日本和風機器人的設計全部都是用 3D 建模後，再以 3D 列印製作而成的。

This samurai robot is modeled and printed by Masaki for the "Go! MyRobot Exhibition." The robot is designed with a Zipang (an antiquated name for Japan) taste.

* 譯：GO！我的機械展〔日本和風篇〕

02. 將液態補土抹在全體表面，並刻意將表面粗糙化後，再塗上黑色→ SUPER IRON → NEW RUST (鐵鏽色)，另一尊白色的機甲則塗上白色和金色做爲區別。

The robot received a rough texture by applying liquid putty to the surfaces with a stiff brush, then received a base paint of black, super iron, followed by rust tones.

03. 因爲想將背景設定爲沉在湖底的巨大機器人，便在長長的石階上製作了鳥居及五重塔，機器人腳邊的參拜道路兩側則排列著燈籠。

A five-storied pagoda was placed on top of a steep hill, with a staircase leading down the bottom of the ocean where the Samurai robot lays still.

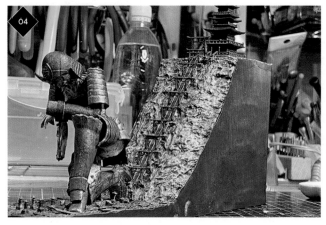

04. 進行地面及五重塔等部分的塗裝。

The ocean floor, the ground, and buildings such as the five-storied pagoda and torii (a Shinto gateway) were painted.

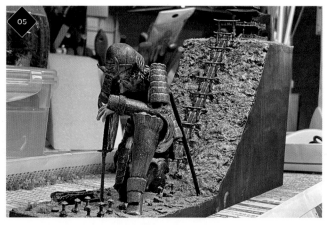

05. 在石階的坡道以及地面等處，以粉末素材追加製作各種植被。

Some areas of the ground received vegetation using diorama materials such as grass powder.

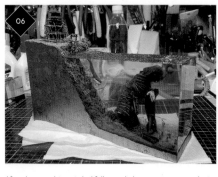

06. 倒入樹脂液，製作出波浪。接著，在機器人的頭上配置一艘航向五重塔的船，增添水面上的故事感。五重塔的周圍種植許多滿開的櫻花樹。地面的側面用金屏風圖樣的和紙來做裝飾。底座最下面的木板使用朱色做塗裝，更能強調日本和風的感覺。

After the poured-in resin had fully cured, the waves were created using a gel medium. A small boat was placed above the robot's head to hint at an interesting story behind the diorama. The vertical sides of the base were covered with washi-style golden paper, with the bottom plate painted in vermilion to emphasize the Zipang-like atmosphere.

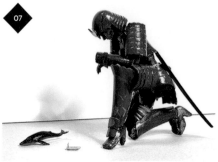

07. 另一尊爲紅色機器人，基本上也是採用相同的順序進行製作，只不過機器人的塗裝是紅色。以紅白兩色來做場景模型，讓整體氣氛也變得比較有喜慶的感覺了。

Another almost identical diorama was built, this time with the samurai robot painted in red. These two dioramas, one in white and another in red, represent Japanese culture's two good luck colors.

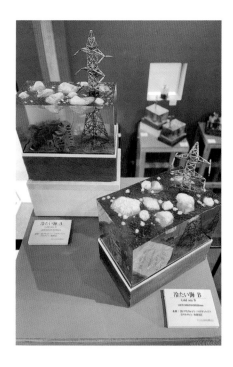

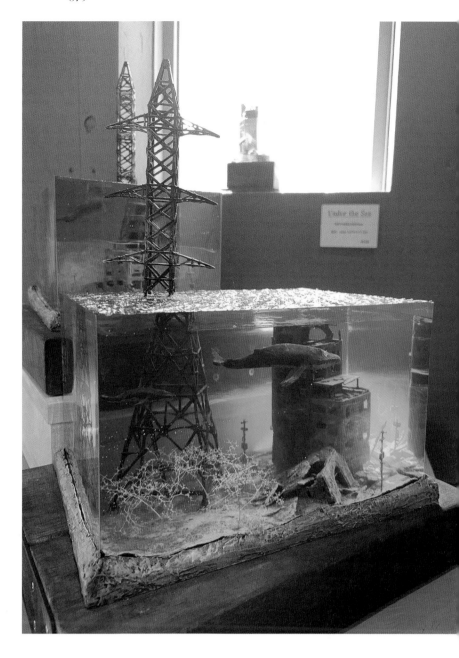

First solo exhibition
of the submerged dioramas

水沒場景模型初個展

2022 年 8 月 18 日至 8 月 28 日，
在東京·谷中的 HOW HOUSE EAST gallery-G，
舉辦 MASAKI 作品展「水沒後的世界場景模型」。
參觀人數超過 1000 人的超級盛況。
雖然是在氣溫超過 30 度的盛夏時期舉辦，
但在帶有清涼氛圍的作品環繞下，
一定有很多人整天待在展場都不覺得炎熱吧！

From August 18 to 28, 2022, MASAKI's exhibition "Diorama of
Submerged World" was held at HOW HOUSE EAST gallery-G
in Yanaka, Tokyo. The exhibition was a great success, attracting
more than 1,000 visitors in total. Although the maximum
temperature was over 30 degrees Celsius, many visitors may
have spent the day surrounded by cool works of art.

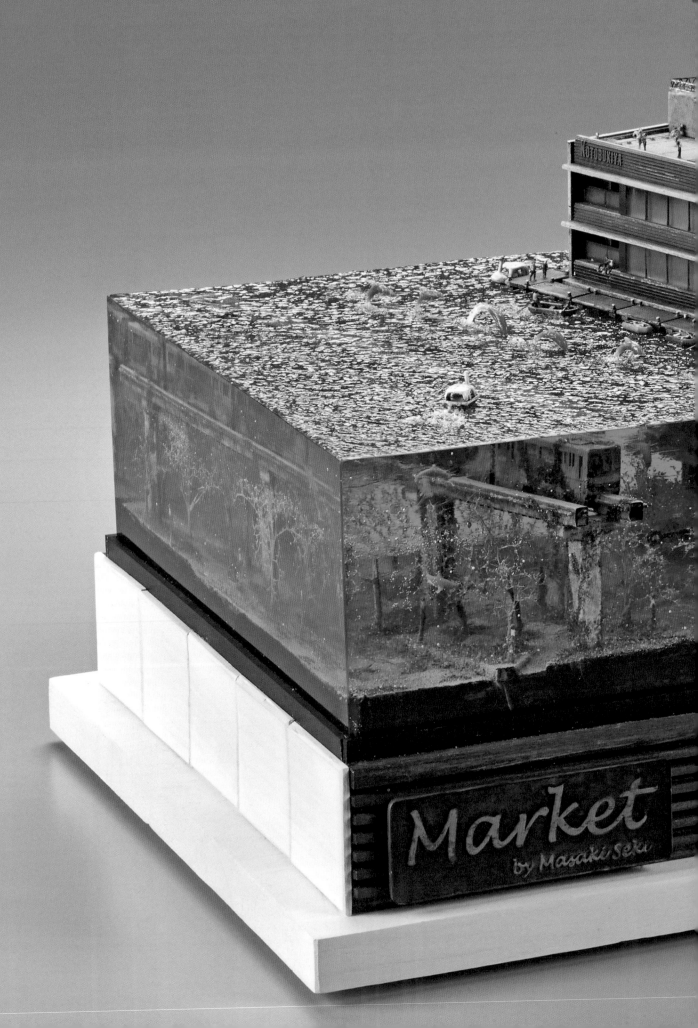

Market
by Masaki Seki

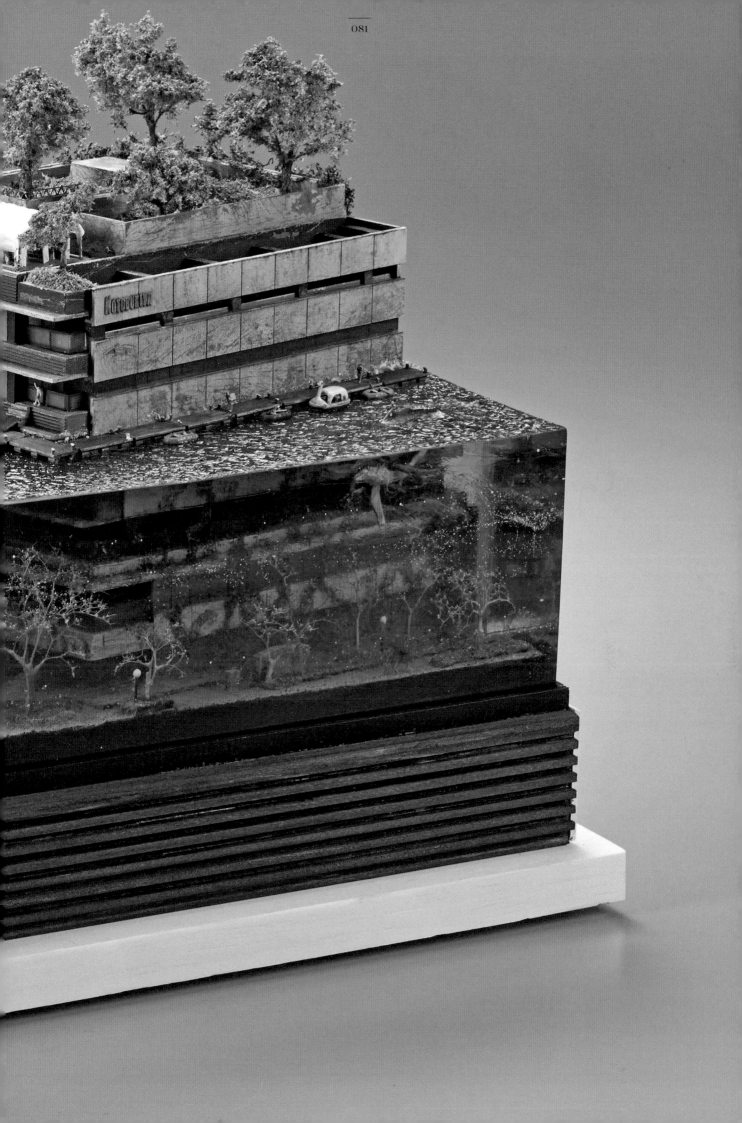

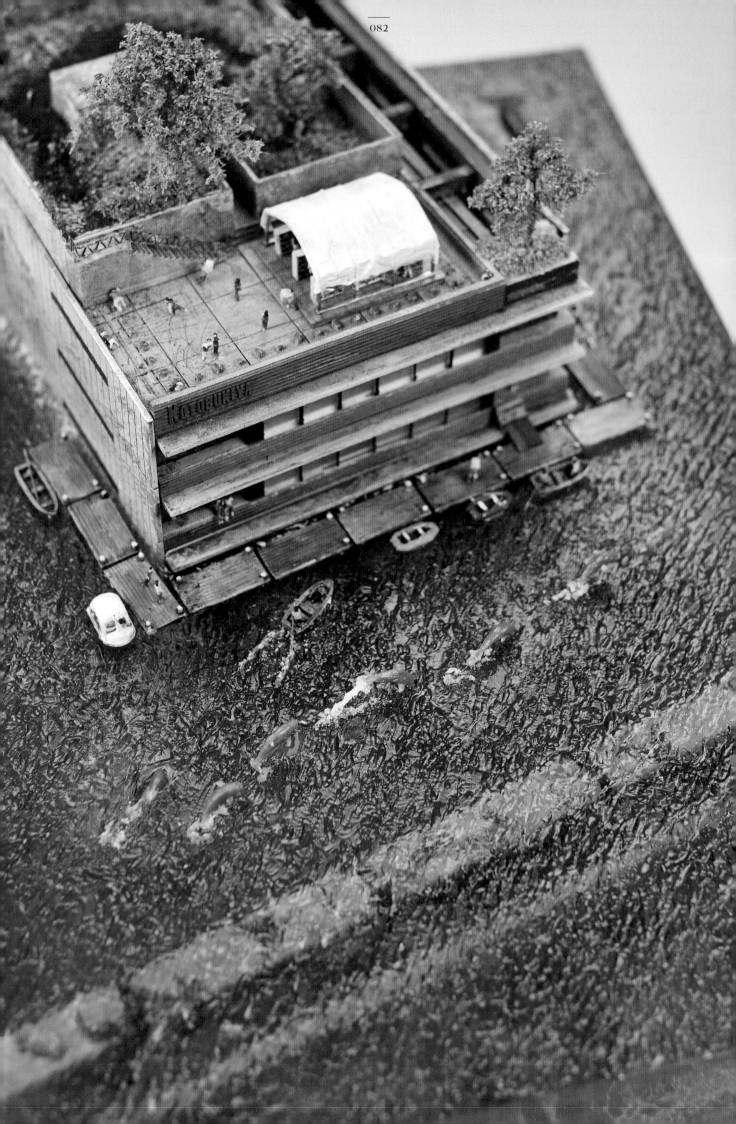

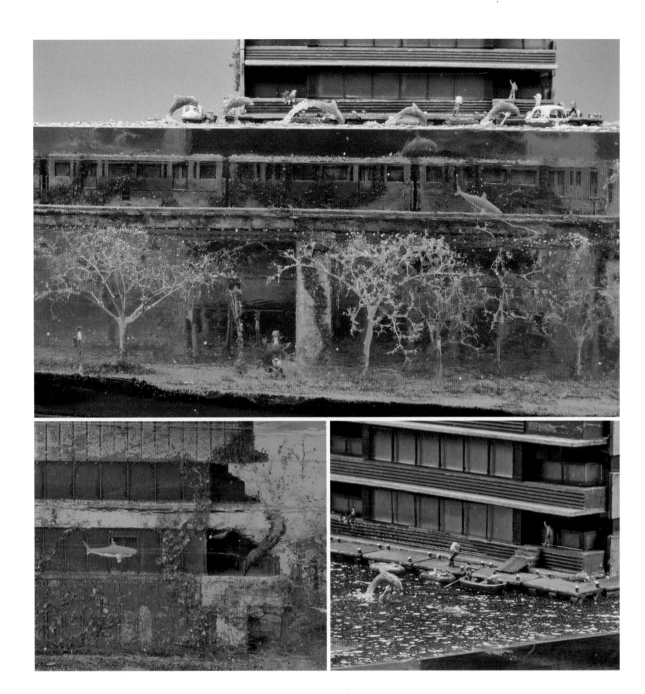

Market

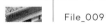 File_009

水没壽屋

□ 2023 年製作（『月刊 Model Graphix』2023 年 4 月號刊載）
□ W:240 ㎜ × D:160 ㎜ × H:220 ㎜

使用 1/300 縮尺比例之壽屋總公司大樓的塑膠模型，重現本社大樓與其周邊風景的水沒場景模型。除了以在網路等管道收集到的周邊景色資料爲基礎，甚至還將多摩單軌電車也以 3D 建模後列印輸出來配置在場景當中，是一件充滿企圖心的作品。因爲是以現在仍在使用中的總公司大樓爲原型，所以作品的氣氛也想要帶有朝氣及活力。配置在屋頂上或水邊的人們也用 3D 列印製作，雖然每個人物都只有大約 5 ～ 6mm 那麼細小，但表情十分豐富，使場景更添活潑的色彩。利用無酸樹脂 GEL 凝膠劑來表現的海面細緻波浪，也十分精彩奪目。

A submerged diorama recreating the Kotobukiya headquarters building and its surroundings using a 1/300 scale kit. Based on information collected from internet, this ambitious diorama have 3d modeled Monorail system. This work was published on Monthly Model Graphix in April 2023. People placed on the rooftop and at the water's edge are also output in 3D, and although each measures about 5 ~ 6 mm, they add expressive color to the scene. The fine representation of the sea surface using gel medium is also excellent.

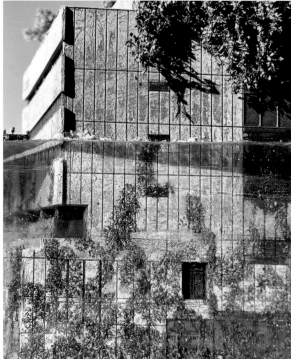

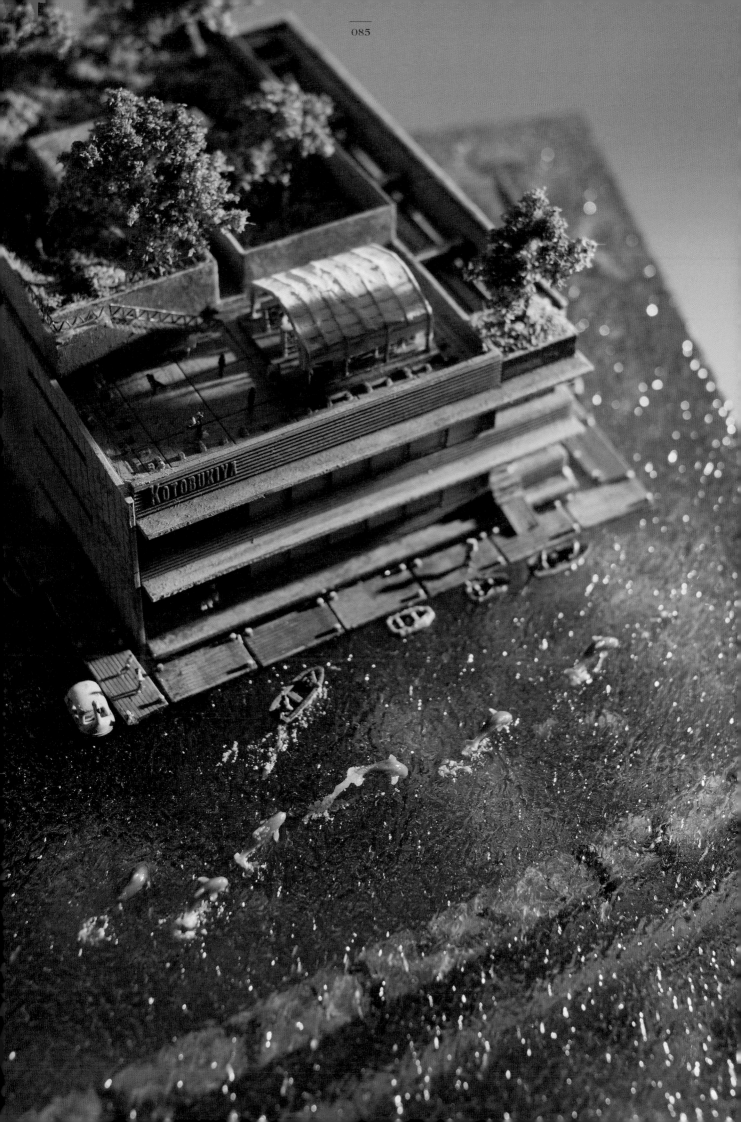

File_009

Market

01. 透過在網路搜尋的方式收集壽屋總公司周邊的圖片資料，再對初步組裝完成的大樓模型進行尺寸量測，然後和行駛在大樓前面的多摩單軌列車一併進行 3D 建模，考量整體的佈局。一旦確定好佈局之後，將完成的 3D 建模列印出來。

After gathering resources on Kotobukiya's office building via Google Maps, Masaki begins the planning phase of the diorama. Once the layout of the diorama was finalized, the monorail and its tracks were 3D printed.

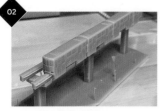

02. 將輸出完成的 3D 模型進行表面清潔與二次硬化，然後剝離支撐材料，並且清潔與整理表面。由於支撐材料附著的表面可能會呈現波浪形狀，要經過打磨來加以整理。

Once printed, all 3D printed parts must be washed and cured for the second time. Support materials were cut off, and wobbly surfaces were sanded flat.

03. 材料如果會透光的話，將導致建築物的比例感不明顯，因此要使用黑色的底漆來進行底層塗裝，然後再重疊塗上灰色。
為了讓表面粗糙，使舊化處理的效果能夠呈現不規則的狀態，這要使用筆刷以輕輕敲打的方式塗上 Liquitex 的胡粉 Gesso 石膏底料。

The building was first coated with black primer to ensure no light seeps through. It was then painted grey, followed by a rough application of Liquitex whiting gesso using an old brush.

04. 將除了玻璃以外的部分都塗上胡粉 Gesso 石膏底料後，使用刻線刀重新挖出牆壁溝槽等被填埋掉的部分。

After applying the gesso everywhere besides the building's windows, fine details such as the grooves between outer wall panels were rescribed using a line chisel.

05. 完成一輪作業後，請重新組裝、再確認一次。由於這個套件的組裝基本上不需要使用到黏著劑，因此這個部分進行塗裝會更容易進行作業。確認完整體狀態後，再次逐個部分進行拆解。

Test assembly of the building. After ensuring everything is lined up correctly, disassemble the building again for ease of painting.

06. 拆解完成後，在進行基本塗裝之前，需先噴上一層較厚的髮膠進行遮蓋保護，然後進行基本色的塗裝。如果塗膜太厚的話，會讓後續刷水剝落處理時水分無法達到髮膠層，使得塗膜無法順利剝落，因此塗層應該要薄一點。

Hairspray was sprayed thoroughly on the model. Paint the building. Keep the paint layer thin, so you can easily flake them off by scrubbing with a brush soaked in water (see step 7 to 8).

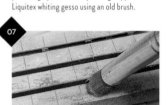

07. 在塗膜表面刻意造成微小刮痕，可以讓水分進入其中，使得塗膜容易剝落。創造刮痕後，將硬度較高的模板畫的筆刷沾濕水分，擦拭想要讓它剝落的部分，這樣髮膠層會因為吸收水分而膨脹，便得塗膜開始鬆動與剝落。

If you have trouble chipping the paint, create small scratches so the water can easily seep through paint layers, reaching the underlying hairspray layer.

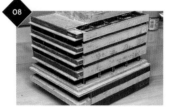

08. 若還是不容易剝落的話，可以讓塗膜保持在含有水分狀態，稍微等待一段時間後，再進行擦拭。當整體按照想像的方式成功完成剝落處理後，再一次組裝、確認。

You could also leave the model wet for several minutes to soak up moisture, which should make the paint chip easier. After you are satisfied with the result, assembly the building once again.

09. 在已經完成組裝的狀態下，將要使用 MR.WEATHERING COLOR 擬真舊化漆的 Grand Brown 色進行漬洗。使用筆刷粗略地塗抹，然後使用面紙輕輕拍擦拭。保留一些不均勻感，讓表面保留污損的質感。

Apply a wash with GSI Creos Mr.Weathering Color Ground brown. Apply with a large brush, and wipe off the excess by gently tapping on tissue paper. Leave more to give the building a more weathered look.

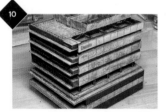

10. 使用筆塗方式重現壽屋 (Kotobukiya) 的公司標誌，然後使用硝基系的表面保護塗料進行表面塗裝。同樣，對單軌的部分也要進行區分塗色，進行漬洗，並施以表面保護處理。

Brush paint the company logo on the building and protect the model with a clear lacquer coat. The monorail and the elevated railway were painted and weathered in a similar fashion.

11. 根據網路圖片的佈局製作地面部分，也可以參考 Google 地圖之類的街景照片。

The layout of the ground level of the diorama was created based on Google Maps images. The Street View feature came in handy as well.

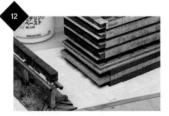

12. 地面使用不同厚度的風扣板進行拼接製作。表面塗抹 MODELING PASTE 塑型土，並呈現出凹凸感。建築和單軌部分可以後續再鑲嵌組裝上去 (此時尚未黏合固定)。

The ground is made by pasting together styrene sheets of different thicknesses. The Unevenness of the ground was simulated with a modeling paste. The building and the railway are not glued to the base at this stage.

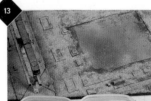

13. 在地面的表面上使用 MR.WEATHERING COLOR 擬真舊化漆的 Grand Brown 色進行漬洗，塗上 Matte Medium 消光劑，撒上兩種不同的粉末素材。地面的側面則使用 Flat Black 來進行塗裝。

Mr.Weathering Color's Ground brown was applied to the ground as a wash. The ground was then coated with matte medium and sprinkled with two types of dirt powder.

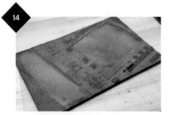

14. 當 Matte Medium 消光劑乾燥後，將沒有固定住的粉末倒在紙上，然後清除。如果有多餘的粉末殘留，在灌注樹脂時可能會浮起來，因此使用空氣吹塵器進一步將多餘粉末吹除。

After the matte medium dries up, tilt the diorama to remove the excess dirt powder to be reused. Make sure no loose powder is left, as they could float up to the surface during the resin pouring step.

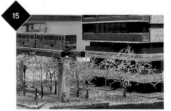

15. 沉入水中的樹木，是將模型用的乾燥樹木的頂端部位幾束捆綁在一起，並使用黃銅線和瞬間膠固定住。樹幹部分塗上胡粉 Gesso 石膏底料，並使用棕色系塗料塗裝。暫時先佈置在地面上一次，確認氛圍。

Trees are created from Dutch dried flowers' tips bundled with a brass wire and super glue. The trunks of the trees were coated with gesso powder to give them a rough texture.

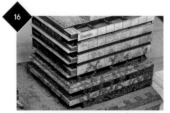

16. 由於建築物內部是空心的，需要使用 Styrofoam 發泡塑料填滿空隙，並在建築物的屋頂鑽出大約 5 個排氣孔。
同時要在可能長出海藻的地方塗上 Matte Medium 消光劑，撒上綠色的粉末。

Since the building is hollow, the insides were filled with styrene boards. Several holes were drilled open on the roof so that the trapped air has an escape route during the resin pour. Seaweeds were added using green powder.

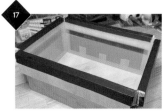

17. 進行模板的製作。如果模板的一邊比較長，作品的上方邊緣可能會因爲樹脂的收縮而出現彎曲。因此要使用強力的雙面膠帶和膠布將木材固定，並進行加固。

Assembly of the molding frame. Reinforce the top 4 edges of the frame with wood planks and strong double-sided tapes so the mold doesn't flex while the resin is curing.

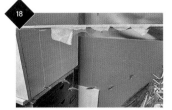

18. 使用釣香魚用的釣魚線，將正在游泳的海豚、鯊魚、鯨魚等物件懸吊在模板上。佈置完所有海中生物後，使用遮蓋膠帶將懸掛著的免洗筷固定在模板上。

Sea creatures like dolphins and whales were hung from the top of the molding frame with fine fishing lines.

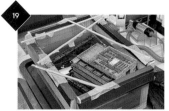

19. 將樹脂倒入至預期的深度。在進行作業的過程中，確認是否有氣泡從意料之外的地方產生，如果有，則將其去除。本次作業是分爲 5 次，總共灌入 2 公斤的樹脂。

Pour the resin. Check to make sure no bubbles are seeping out from an unexpected part of the diorama. Remove bubbles accordingly. A total of 2 kg of resin was poured in five separate batches.

20. 等樹脂完全硬化之後，需要小心移除模板，避免在側面造成損傷。移除模板後，可以看到樹脂在表面張力的作用下出現凸起形狀，以及模板接合處可能會有毛邊。使用超音波切割刀將這些部分切除修整，盡量使其平坦。

Once the resin is fully cured, remove the molding frame. Scrape off the excess resin at the top to completely flatten the ocean's surface. The use of an ultrasonic cutter is recommended for this task.

21. 切割並修整完成後，接著使用 120 號到 10000 號的砂紙進行打磨，直到達到一定的透明度。

The excess resin is cut off and polished using 120 to 10000-grit sanding paper.

22. 只要處理到在表面灑水後可以感覺到透明度的狀態，後續在塗上 Gel Medium 壓克力凝膠時就會變得透明。打磨作業大致上要以這個程度爲目標。

To check the transparency of the resin, apply some water. If the resin becomes clear, proceed to the next step (application of gel medium).

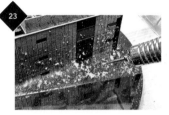

23. 海面的波浪，即使在平坦的表面塗上 Gel Medium 壓克力凝膠，從低角度仰望水面時，仍然難以看見水波的紋理。因此，這次我們使用了手持式電動刻磨機實際將波浪的形狀加工出來，以便即使在水下也能輕易看到波浪。

In order to create a more dynamic and realistic wave for this diorama, Masaki decided to first sculpt the rough shapes of the waves using a dremel tool.

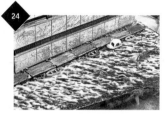

24. 如果只是簡單地削去表面樹脂，仍然缺乏波浪的表情，因此要再使用 Gel Medium 壓克力凝膠來添加細微的波浪形狀，並在波浪的上方放置棧板碼頭和小船。跳躍在水面上的海豚濺起的水花等效果也是以同樣的方式加以重現。

Finer waves were added using a gel medium. Smaller details, such as the piers, boats, and jumping dolphins, were added to the diorama by pressing them onto the still-wet gel medium.

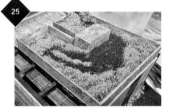

25. 屋頂上的戶外機器安置場所由於「在這種情境下早已失去原有功能，乾脆決定將從其他地方運來的泥土堆成一個公園」。因此就堆上了木粉黏土。待黏土乾燥後，使用茶色和綠色的粉末來表現土壤和草地。

The rooftop of the actual Kotobukiya building is utilized as a space to store outdoor units of the air conditioner. Since these would be pointless in a post-apocalyptic scenario, the rooftop was converted into a garden.

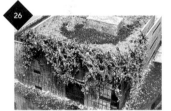

26. 從屋頂牆面垂掛下來的藤蔓使用了迷你番茄的根，或是 Mini-Natur 微縮花草的藤蔓素材。由於根部在乾燥後容易斷裂，因此在貼附時需要先用水沾濕。爲了使藤蔓看起來不會太單調，這裡還在藤蔓上添加了明亮顏色的粉末。

The ivy hanging from the rooftop wall is made of mini-tomato roots and Miniart's diorama sets. Roots tend to break when dry, so water is added to soften them before gluing them to the roof.

27. 由 3D 列印機輸出的人物尺寸爲 1/300，因此在實際尺寸上約爲 5 ～ 6mm。由於這次希望人物能有多種動作姿勢和不同的性別，所以是購買了免版稅低面數多邊形人物數據來加以活用。

Human figures were 3D printed on a 1/300 scale (5 to 6mm in height). The low-poly and royalty-free 3D model data were purchased from a website.

28. 場景模型的底座是以木材製作。在底板上開有兩個孔，方便嵌入搬運時用來固定的埋入螺帽。木質部分的塗裝，使用的是 Pore Stain 水性透明塗料，或是硝基系噴漆。

The base of the diorama was made of wood. Two holes were drilled on the underside of the base for convenience during transportation. Wooden sections were painted using water-based stain and lacquer spray.

29. 將場景部分接著固定至木製底座。這裡使用的是 Cemedine Super-X（接著劑）。

The diorama and the base are glued together. Cemedine's Super X glue was used as an adhesive.

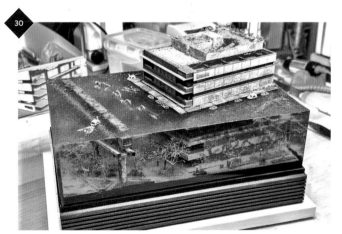

30. 最後添加人物、屋頂上的樹木等，整個場景模型就大功告成了。

Place the rest of the details, such as human figures and rooftop trees, to mark the completion of the diorama!

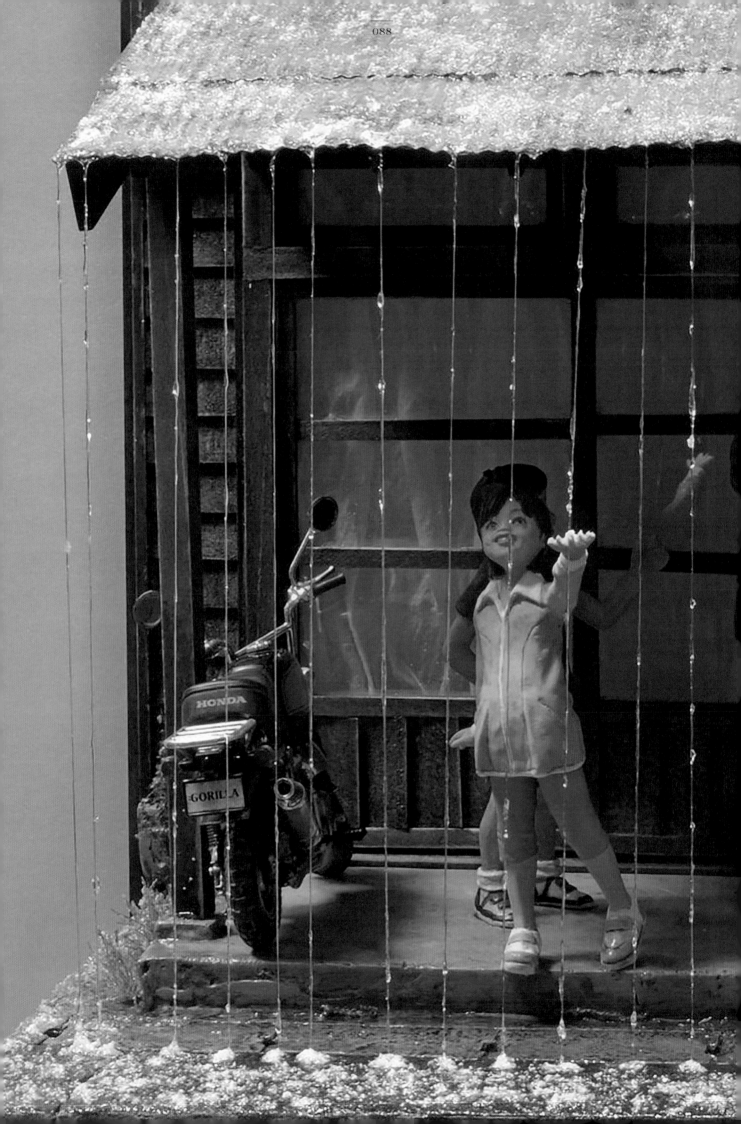

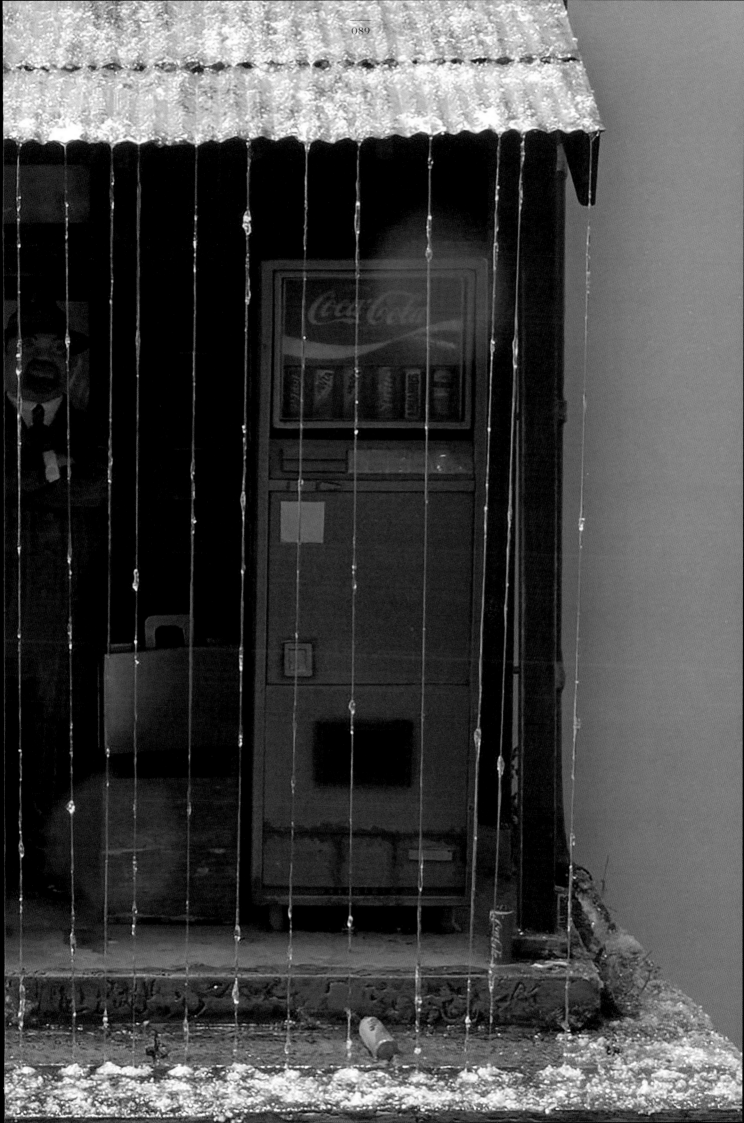

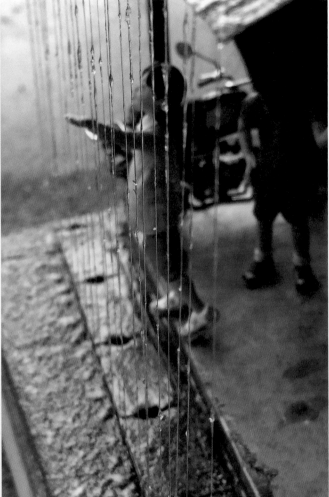
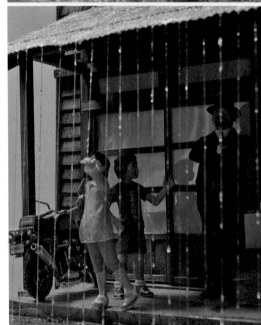

Shelter from the rain

儘管之前已經以 1/72 比例製作過雨天的場景，但因為雨的表現太誇張，超出規模比例，因此改用 1/20 比例的人物模型進行重新製作。從鐵皮屋頂和地面上彈跳的雨滴，到從鐵皮屋簷滑落的雨水等，細緻的水滴表現突顯出細節的質感。具有懷舊氛圍的老式自動販賣機是全手工製作的，包括建築物都是使用檜木棒等材料自製而成。能夠收入掌中的精緻世界被懷舊的氛圍所包圍，由此可以一窺 MASAKI 作品表現的廣泛性。

屋簷下躲雨

□ 2017 年製作（刊載於月刊《Armour Modelling》2019 年 9 月號）
□ W:200 ㎜ × D:100 ㎜ × H:250 ㎜

The rain scene had been previously produced at 1/72 scale, but since the rain representation became over-scaled, it was re-produced using 1/20 scale figures. Finished as a very compact diorama. The subtlety of the expression of water in the details, such as the drops of rain that bounce off the tin roof and the ground, shows through.The vending machine, with its old-fashioned, nostalgic feel, is scratch build. There was no building at 1/20 scale that fits his image so he made his own from cypress sticks. The compact world that fits in the palm of your hand is wrapped in a nostalgic atmosphere, and you can catch a glimpse of the breadth of expression in MASAKI's work.

01. 將建築物的尺寸以 1/20 比例繪製在圖面上,再切割出所需的木材,以木工白膠黏合起來。如果不事先繪出建築物的圖面就直接製作的話,即使是微小的扭曲或尺寸差異,也可能會形成不自然的違和感。

The 1/20 blueprint of the building was drawn, and all the necessary parts were cut out from wooden blocks and sheets. These parts were then glued together using wood glue.

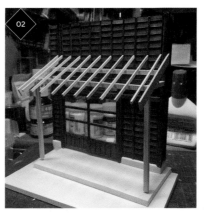

02. 使用水性的黑色 PORE STAIN 水性染色劑上色木材製作成的牆面,並使用砂紙等工具將表面修飾成類似褪色的效果。連鐵皮屋頂也是從骨架開始製作。

The wooden walls were stained and colored using water-based paint called "Pour stain." The walls can be sanded to expose their natural color, giving the building a faded, worn-out look.

03. 從雨水槽中流出的排水,是使用塗抹了 Gel Medium 壓克力凝膠的透明柔軟塑料棒進行製作,藉以呈現傾盆大雨的效果。在自動販賣機旁邊的柱子前面,放置了有人抽過的香煙煙蒂和空罐子。

The water drainage from the gutter is created by applying a gel medium to a transparent plastic rod, indicating heavy rainfall. Empty soda cans and tobacco was scattered around the base.

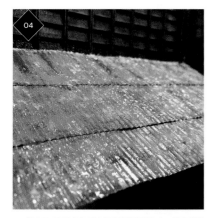

04. 鐵皮屋頂是將鋁板放在鋸齒狀的塑料板上,按壓溝槽製作波浪形狀。藉由塗裝重現鏽蝕感,並使用水泡效果素材和 Gel Medium 壓克力凝膠表現雨水濺起的水花。

A thin aluminum sheet is placed on and pressed against a special jig to create a tin roof. These were painted in rusty tones, and Morin's water bubble expression material combined with gel medium was applied to replicate the heavy downpour of rain hitting the roof.

05. 地面使用的是珍珠板,並將購自價格均一商店的木製小物件容器倒放在上面。

The ground is made of a styrene board and attached to an upside-down wooden accessory case purchased in a dollar shop.

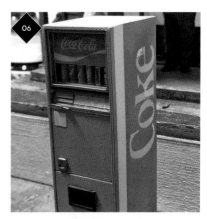

06. 自動販賣機是由塑料板組裝製作而成。在網路上搜尋老照片,從中計算出尺寸並進行重現。藉由稍微褪色的紅色,以及剝落的塗料,呈現出老舊的感覺。

The vending machine is built from plastic sheets. Masaki google searched for an old vending machine, got its dimensions, and accurately replicated it on a 1/20 scale.

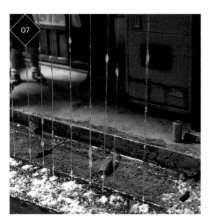

07. 從屋簷垂下的雨滴以釣香魚用的尼龍線製作而成。使用瞬間接著劑點一下,將尼龍線黏合固定在屋簷下方,並把線拉到屋簷邊緣固定住。剪掉多餘的尼龍線,使用 Gel Medium 壓克力凝膠來表現雨水。

The rainwater dripping from the roof was created using an elastic fishing line. Gel medium was applied to these threads to give a more dynamic feel.

08. 攜帶用的箱子是以價格均一商店買來的珍珠板先組裝成盒子後,然後使用保護用的塑料板包覆在外側製成。

The carrying case for the diorama is specially built to accommodate this model. The carrying case is made from styrene boards and plastic cardboard.

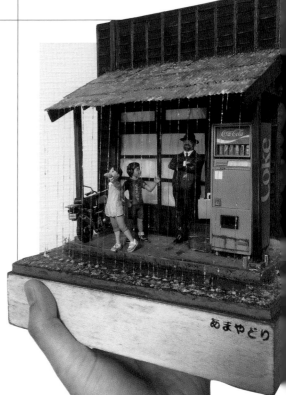

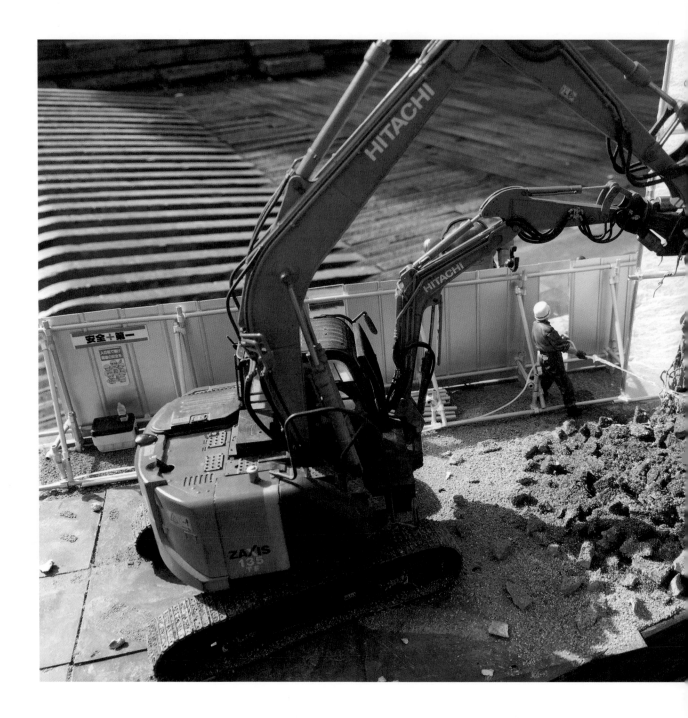

Longing

 | File_012

心之所嚮

☐ 2016 年製作
☐ W:300 ㎜ × D:200 ㎜ × H:250 ㎜

這件作品使用了 1/35 比例的 Hasegawa 製造的雙臂重機 Astaco NEO，先營造出一個日常的風景，再將相同比例的 Mechatro WeGo 融入其中，最終呈現一種充滿近未來感的氛圍。少年的視線注視著 Astaco NEO 的駕駛員，而站在旁邊的 WeGo 則凝視著 Astaco NEO，然後工地上的工人則對著女高中生望去。每個角色的視線所指之處都各有所嚮，形成一個充滿幽默感的構圖，將心中憧憬的存在放置在各自的視線前方。工地圍欄內的氛圍也經過精心安排，像是管道的組裝方式和地上鋪著鐵板的作業環境，讓人感覺宛如真實，具有極高的品質。雖然這在 MASAKI 的作品中屬於水的元素相對較少的難得作品，但這仍然是一件足以展現 MASAKI 所擁有的情景表現力和豐富想像力的作品之一。

Using Hasegawa's 1/35 scale ASTACO and Mechatro WeGo, it is a diorama finished with a near-futuristic atmosphere. Every character line of eyesights makes this composition very humorous. The atmosphere inside the construction site has been carefully created, and the way the pipes are assembled and the laying iron plate has a quality that resembles a real thing. Although the element of water is rare in this work, it is one of the build that shows the expressiveness of the scene and the richness of MASAKI'sideas.

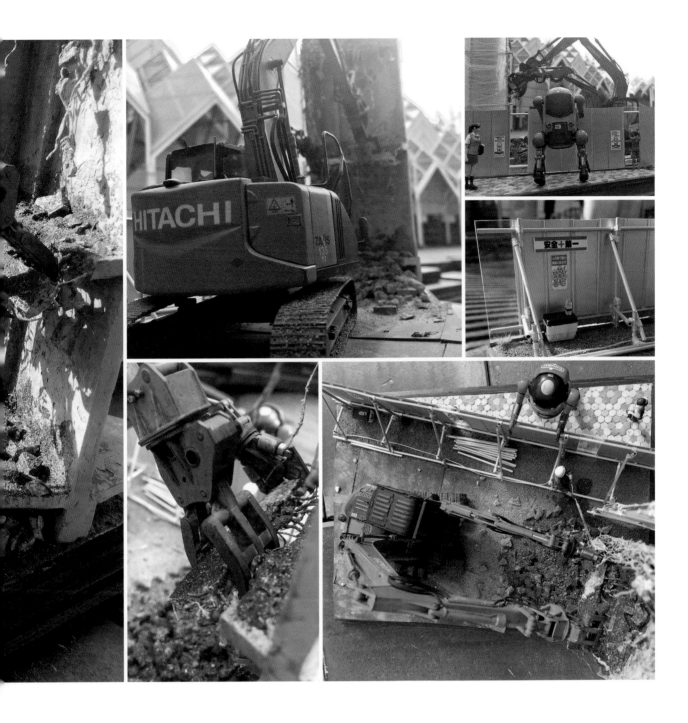

TOMOKAZU
SEKI
MASAKI

關 智一 × 關 眞生

日常與非日常的融合

聲優關智一與沉水場景模型創作者 MASAKI，
雖然兩人身處完全不同的行業，實際上卻是互相尊敬的關係。
這次，實現了這場由兩位進行的對談。
「模型」是他們共同的話題，也是他們相識的契機。
透過這次對談，兩人分享了彼此相識的契機、模型與工作之間的聯繫以及 MASAKI 作品的吸引力。

水中的「非日常」和水面上的「日常」之間的平衡，是其他人無法模仿的，實在太了不起了！

關 智一

——首先想請教兩位是怎麼相識，或者說是認知到對方存在的契機。

關 智一（以下簡稱「關」）：其實是從我追蹤 MASAKI 老師的 Twitter 開始的。

MASAKI（以下簡稱「M」）：看到被追蹤的時候，真的是嚇了一跳。

關：我本來就喜歡在 Twitter 上觀看模型的照片。我經常會去搜尋或者觀看出現在我的時間軸上的照片。有一天，MASAKI 老師的作品照片出現在我的推特上。雖然我現在不太敢肯定，但我記得那是一件機動戰士被淹沒在水裡的作品。水中不斷冒著氣泡，看起來非常有真實感。於是我馬上追蹤了作者。

M：被關先生追蹤的時候，我有點驚訝，心想：「咦！這個人是真的嗎？」（笑）。因為我也是動畫的愛好者，本來就知道關先生，所以當時感到非常驚訝。馬上查看帳號確認「好像真的是本人」，於是立刻追蹤他。不過這已經是相當久以前的事情了……實在記不太清楚了。

關：我純粹是看了作品就喜歡上了，所以我只是其中一位普通的粉絲而已。能夠被 MASAKI 老師邀請進行對談，實在是感到非常心虛。

M：因為我們倆的姓氏都是「關」，所以感覺很親切，再加上關先生有著令人難以忘懷的聲音和演技，因此在 Twitter 上發生的事情，使我變得更加關注你。有時候，還會查詢你曾參與的作品，並且找影片觀看。

關：實在是非常感謝。

——兩位是這樣開始產生了聯繫呀！關先生認為 MASAKI 老師的作品魅力是什麼呢？

關：當然，最大的特點是被水淹沒的場景了，但其實水面的表情也很有趣。有一種在非日常中誕生的日常。廢墟的悲涼氛圍和海面上的「生命力」之間形成了反差。而且，如果有船經過的話，會拉出一條航跡，波浪的感覺也很棒。就算放在家裡當室內裝飾，也一點都不奇怪，作品很有時尚感。可能因為 MASAKI 老師本業是設計師的緣故，使得整個作品有很高的設計感。像我主要是玩人物模型，從來沒有製作過場景模型。所以對像這樣的情景作品一直有一種憧憬。當作品變成情景作品時，敘事性就會一下子增加，不是嗎？或許正因為是我自己從未嘗試過的事物，所以更加被吸引也說不定。不禁會去想著這是從哪裡來的靈感，又是如何製作出來的呢？所以我認為 MASAKI 老師的作品有很多值得尊敬的地方。我自己很喜歡製作東西，所以看 MASAKI 老師的 Twitter 對我來說是一種樂趣。最近好像看老師製作了一個皮包之類的東西吧。

M：你真的知道得很清楚呢（笑）。我才剛開始製作這個題材，所以還做得很拙劣……。

關：我也有很多喜歡製作東西的朋友，當他們看到 MASAKI 老師的作品時，也都不禁會被那些有品味的作品所震撼，覺得真的「好厲害」。MASAKI 老師製作的那個躲雨的情境作品，真的不知道是怎

麼做的呢！光是選擇雨天這個主題就很厲害了。

M：一般來說雨天的情境就是撐著傘、地面濕漉漉的感覺啦，但我真的想要表現的是「正在下雨」的感覺。一開始是以1/72 比例的《聖戰士丹拜因》為主題製作的，但因為場景比例太大了，所以又以 1/20 比例重新挑戰一次。

關：透明的材料本來處理起來很困難，而且你居然還想要呈現出下雨的感覺，真的很厲害。這個雨水是用什麼方法製作的？

M：我使用了釣香魚用的釣魚線。然後塗上一種叫做「Gel Medium（壓克力樹脂凝膠）」的透明材料，用來表現雨滴的效果。在其他作品中，我也曾經使用釣魚線懸掛物件，然後再以透明樹脂填埋包覆，重現水中漂浮的狀態。

關：釣魚線是放進去之後就會變得看不見嗎？

M：我用的是細如蜘蛛絲的釣魚線，所以完全看不見的。

—— 您在其他作品中，也有使用透明的珠鏈來將物件固定在水中的方法。

M：平常我都會收集這樣的材料。去價格均一商店逛的時候，也會看看有沒有「這個說不定可以用在模型上」的東西。偶爾還會被女兒問道「這個壞了，你要不要？」之類的。

關：通常如果沒有把這些東西收集在手邊，當真正需要使用時就會變得一籌莫展了。

M：只要先收集起來堆放在家裡，製作的時候就會浮現「那個說不定可以用」的各種靈感，對提高製作速度也有所貢獻。

關：MASAKI 先生的創意想法也非常靈活呢！我之前曾經問過一位模型創作者「這部分是用什麼做的？」，他居然回答「我用的是牙籤的尾端」。優秀的模型創作者會將日常生活中看到的東西，適當地應用到模型製作中。他們都擁有打破既定

概念的創意想法。這道理在表演中也是如此，打破既定概念非常重要。做一些不同尋常的事情，可以呈現出更加有趣的演出，所以我認為這種靈活的思維能夠產生出更多好的作品。相比之下，我可能看起來很靈活，但實際上是那種無法違抗世俗觀念的人（笑）。所以從這個意義上說，這部分也許是我之所以會尊敬MASAKI 老師的原因之一了。

除了是聲優，
也是原型師，
同時還是完成不了作品的
模型創作者

—— 聽說關先生以前在《月刊 Model Graphix》上有自己的連載專欄，是位相當有名的模型創作者。

關：是的。有段時期我每個月都會製作一個作品範例。

M：您工作這麼忙，真了不起呢！您一直有在製作角色人物模型嗎？

關：我從小就喜歡製作角色人物的模型。小學的時候，海洋堂在茅場町開了一間Hobby Lobby，我常去那裡學習製作模型的方法。

M：真是了不起的小學生（笑）。

關：在 Hobby Lobby 的後台有一個工作人員製作作品的工作室，我會把在家製作的模型帶去那裡給他們看。有一次對方告訴我「腿部肌肉結構這樣是不對的」，然後當場就把我的作品拿去刮刮削削……

M：現在很難想像還有這樣的教學方式，有點斯巴達式教育的感覺。

關：對方還說過「我先幫你修好一隻腳，另一隻腳在家看著這個來修改吧！」，「如果製作得好，海洋堂就會幫你發售作品」這樣的話。那時喜歡製作模型的年輕人都聚集在那裡，實際上有些人的作品也確實獲得商品化的機會了。這段小

學時期的經歷一直延續到現在。

—— 您開始連載的契機是什麼？

關：當時因為我參與了《機動武鬥傳 G GUNDAM》的配音工作，而《月刊 Model Graphix》為了製作特刊來採訪我。當時的編輯和我年齡相仿，所以我們很投緣，這就是開始的原因。我們是私底下也會互聊的交情，有一次我去旅行，對方告訴我「帶點伴手禮回來給我」，而我卻什麼都沒有買就回去了。於是我就說：「那不然就讓我來寫連載專欄吧！」，接著這個企劃順利得到通過，所以我的連載就這樣開始了。當時固定有刊登關於《GUNDAM》的文章，但更偏向戰車和戰艦這類硬派內容，所以有一種一個聲優居然連載這種內容的違和感（笑）。最後對方對我說：「在模型雜誌上老是刊登聲優的專欄好像有點奇怪，所以還是請您好好製作模型吧！關先生！」，我回答：「哦，好的！」，之後就是每次都很認真地製作我的模型作品。

M：您製作過什麼樣的作品呢？

關：一開始是特攝作品《戰鬥電人查勃卡》的可動人偶。我從小學時期就像這樣一直重複製作、把玩一下，再放著不管，不斷這樣循環。當我告訴對方，我家裡有一件《查勃卡》的未完成品時，編輯就說不然就把他做完吧，於是完成那件作品的過程就成了一篇文章。然後這件事吸引到 MAX 渡邊先生的注意，他說：「這正是 GK 套件的精神呀！」，最終我的作品成了由 Good Smile Company 發售的軟膠角色人偶。後來每個月我都得製作一個作品範例了……。

M：那時候，你應該也很忙吧？實在太辛苦了。

關：之後的 10 年，每年我都會製作兩個軟膠人偶。記不太清楚了，也許時間還要稍微短一些吧。我和一位專業人士合作參加了 Wonder Festival，起初他對我很和藹，但漸漸地變得嚴苛起來……當

在享受模型製作的同時不斷地精進技巧。
對事物的看法也能夠應用於各種不同的領域。
關先生在這個層面來說，真的是名符其實的專業人士呢！

關 真生 MASAKI

然，他的出發點可能是爲了我好，但因爲我的本業也變得愈來愈忙，最後我情緒爆發說道：「我不是專業人士，不可能做到那麼高難度的事情！」，最終我生氣地離開了。現在回想起來，真的有點不應該。對方是真的爲了我才那樣要求的。

M：但您從小學時期一直持續到成年都有在製作作品呢。相比之下，到了中學和高中時期就放棄模型的人很多。

關：就像在《查勃卡》例子中看到的，我就是那種根本完成不了作品的模型創作者。稍微摸一下就停下來，所以現在還有很多半途而廢的作品。製作技術基本上是以在海洋堂學到的爲基礎，所以到現在還有很多我不懂的事情。使用石粉黏土進行塑形這部分，我大概還能勉強做得出來。但複製之類的就是有樣學樣模仿著做了。所以我對未知的領域充滿

憧憬。以 MASAKI 老師爲例的話，像我對於電飾之類的就完全不懂。你看，這件作品的顏色一直在變化，真是厲害呢！

M：市面上有賣一些像這樣容易製作的套件，我是利用這些套件進行改造的。

關：真厲害。原來那些看起來很精細的作業，原來這麼簡單啊！

M：就是盡可能地活用現成的材料，耗費最小的工夫去做出好的效果。

關：如果能像這樣事半功倍就好了。我最不擅長製作精細的物件，因爲個性太急躁。模型製作需要耐心和一連串精細的作業，對吧？所以我也不擅長塗裝。

M：像是在塗層還沒乾透的時候就忍不住去碰觸之類的嗎？

關：被你說對了，正是如此（笑）。所以一直到最近才總算能夠真正做完一件模型。我是在 45 歲後，才第一次認真地去

組裝、上色，真正完成一件 GK 套件。但是還有更多是買回來後只動了一點點的套件，所以我可能依舊是一個扶不起來的模型製作者（笑）。

**工作和興趣
形成相輔相成的連結！**

關：MASAKI 老師是以怎樣的頻率製作作品的呢？

M：像委託作品這類設有交期的時候，我會確實在那之前完成作品。但是那些沒有壓力的作品，我就會按照自己的節奏來製作。

——您每天都在什麼時間進行作業呢？

M：因爲我都是在工作結束後回家才開始

製作的，所以平日大約是在晚上9點或10點左右開始。當我全神貫注的時候，有時候會一直做到深夜2點到3點。

關：這麼聽來，製作模型等於是在日常生活中的一個調和劑。正因爲有這個調和劑，讓白天的工作也變得順利嗎？

M：是的，確實如此。我的本業工作是在CG上進行作業，也就是在顯示器裡觸摸物體。所以，當我想實際用手觸摸並創作一些東西的時候，就會回到模型的世界。以前我一直到中學爲止都有在創作模型。當我將完成品上傳到『mixi』平台上的時候，可以得到很多人的回應和評論，這也讓我感到很開心。畢竟平常大部分的工作都因爲有保密協議的關係不能告訴別人，而且很多時候我的名字也不會出現在工作中的製作團隊名單上。

關：那麼這次這本書的出版，在這方面來說確實很切合需要。一個人獨自看著完成品，很容易會讓人感到厭倦。

M：收到觀看者的意見，就會有想要回應的心情。有了個人的興趣，在本業工作上的動力也跟著提高了。可能我也有將在CG工作中獲得的知識應用在興趣上也說不定。CG在一開始的時候只有灰色一個顏色的。想要提高質感，就需要在頭腦中拆解分析各種參數要如何設定。像是「這個物件的表面很光滑，所以漫射光的效果應該不明顯」、「那麼高光部分應該怎麼處理呢？」這樣一連串的考量。從這樣的一步一步的設定過程中，可以逐漸創作出具有真實感的物件。模型製作也是一樣的，如果只是將所有物件都塗裝成霧面的話，反而難以呈現真實的質感。

關：雖然建築物看起來很擁擠，但構成每棟建築物的要素都有其個性，而這些元素又匯聚在一起形成一件作品，所以看起來很自然，是吧？

M：像是要先用黑色塗裝物件避免透光，如果是金屬材質的話，底層要塗上銀色的塗料，然後再塗上生鏽的顏色，這樣

關智一（SEKI TOMOKAZU）
作爲聲優參與衆多動畫與外國影片的配音，同時作爲演員參與了舞台劇和電視劇，並擔任綜藝節目的主持等，目前在多個領域都活躍著。
作爲聲優的主要代表作品包括：
「機動武鬥傳G鋼彈」中的多門・火州、「哆啦A夢」中的小夫／骨川小夫、「妖怪手錶」中的威斯帕、「鬼滅之刃」中的不死川實彌、「PSYCHO-PASS心靈判官」中的狡嚙慎也、「交響情人夢」中的千秋眞一、「JOJO的奇妙冒險 石之海」中的普奇神父等角色。
參與深受兒童歡迎的角色，同時也參與吸引成年觀衆的作品，展現廣泛的演技和實力。

在呈現表面受損的狀態時，就可以讓底下的金屬本來的顏色顯現出來等等。我非常重視這種對於質感呈現的巧思。

關：有些人會在底層塗上像迷彩一樣的各種不同的顏色，然後再開始塗裝上層的顏色。感覺上有點類似這樣的手法。

──MAX渡邊先生就是這樣做的。

關：以這樣的方式塗裝出來的質感，比只是塗上單色要好很多吧。下次我自己塗裝的時候也想要試試看。

──關先生是否有感受到過本業工作與模型之間的關聯性？

關：這個嘛……雖然這麼說起來會有點模糊，但我覺得我在做的所有事情都是相互關聯的。尤其在製作東西或是想要精通某個領域的時候更是有此感受。先要去觀察對象的事物，然後再思考如何以自己的方式表達出來。這種精神在製作模型和演技之間有其相似之處。雖然與前面提到的固有概念不一樣，但我會去思考如何使事情看起來更有趣。有一句諺語是這麼說的：「一芸は道に通ずる（一精百通）」，我真的覺得這句話很有道理。

M：實際上精通某事的人，即使做其他事情也相當擅長。關先生在這個層面上來說，也可以稱得上是專業人士了。

關：對事物的理解方式一旦超過一個特定的程度後，就能在各種事物上應用自

如了。我想應該是這樣。

M：那就是說只要在享受模型的樂趣的同時，繼續不斷精進就可以了吧！

關：所以說，我也是在完成了一件模型之後，才開始大量購買GK套件回來製作的！

──因爲您開始有了想要完成作品的想法了。

關：以後我想要更盡情地享受製作模型的樂趣，所以我很羨慕MASAKI老師。我也想要製作像這樣的作品。請讓我當您的徒弟吧！

M：真是太客氣了（笑）。只要您遇到不懂的事情我都知無不言，歡迎隨時過來找我！

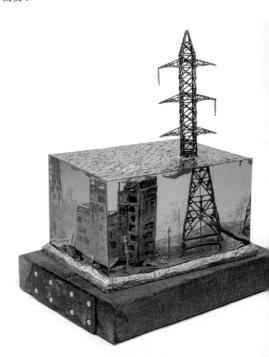

UNDER the SEA
MASAKI 水沒場景模型作品集

Special thanks

關 智一
太田垣康男
インタニヤ
モリナガ・ヨウ
もやし
吉岡和哉
小野正志
石塚 眞（Art Box）
Model Graphix編輯部

（敬稱省略・順序無特定）

國家圖書館出版品預行編目 (CIP) 資料

UNDER the SEA：MASAKI 水沒場景模型作品集 /
關 眞生著；楊哲群翻譯 . -- 新北市：
北星圖書事業股份有限公司 , 2024.07
100 面；21x29.7 公分
ISBN 978-626-7409-60-2(平裝)

1.CST: 模型 2.CST: 工藝美術 3.CST: 作品集

999 113001559

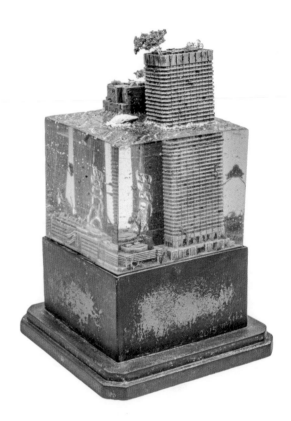

作　　者　關 眞生(MASAKI)
翻　　譯　楊哲群
發　　行　陳偉祥
出　　版　北星圖書事業股份有限公司
地　　址　234 新北市永和區中正路462號B1
電　　話　02-2922-9000
傳　　眞　02-2922-9041
網　　址　www.nsbooks.com.tw
E-MAIL　nsbook@nsbooks.com.tw
劃撥帳戶　北星文化事業有限公司
劃撥帳號　50042987
製版印刷　皇甫彩藝印刷股份有限公司
出 版 日　2024 年 07 月

【印刷版】
I S B N　978-626-7409-60-2
定　　價　新台幣 550 元

│ 臉書官網 │　│ 北星官網 │　│ LINE │　│ 蝦皮商城 │